An Approach to

Figure Painting

for the Beginner

An Approach to

Figure Painting

for the Beginner

By

Howard K. Forsberg

Published by NORTH LIGHT PUBLISHERS, a division
of FLETCHER ART SERVICES, INC., 37 Franklin
Street, Westport, Conn. 06880.

Distributed to the trade by Van Nostrand Reinhold
Company, a division of Litton Educational Publishing,
Inc., 450 W. 33rd Street, New York, N.Y. 10001.

Manufactured in U.S.A.
First Printing 1979

Library of Congress Cataloging in Publication Data

Forsberg, Howard K
 An approach to figure painting for the beginner.

 Bibliography: p.
 Includes index.
 1. Figure painting—Technique. I. Title.
ND1290.F68 751.4'5 79-19504
ISBN 0-89134-023-8

Edited by Fritz Henning
Designed by Fritz Henning
Composed in 10 point Caledonia
by John W. Shields, Inc.
Printed and bound by Rose Printing
Color Printing by Rose Printing

Dedication

This book is dedicated to my daughters
Karen, Nancy and Julie.

Howard Forsberg paints the figure with style and verve. His far-flung art career uniquely qualifies him to show and tell the beginner — and the not so beginner — a sound approach to drawing and painting the figure. The knowledge and skill required to simplify the complex and to tell about it in easy to understand terms is based on a lifetime of performance.

Born and raised in Wisconsin, Howard grew up in a family of artists. After a short stint of studying art in Milwaukee he became an apprentice in a large Chicago art studio. Soon the young artist was turning out commercial work for clients such as Coca-Cola and Budweiser. Within ten years the Howard K. Forsberg signature was appearing on major illustrations for Colliers, Woman's Day, Reader's Digest and other national publications. While continuing his productive illustration career, Howard proceeded to Los Angeles to head a large art studio. After nearly 15 years on the West Coast the Forsbergs returned to the East when Howard was offered a position as painting instructor at the Famous Artists School in Connecticut.

Landscape, seascape and portrait painting along with mural commissions engrossed the artist in recent years. The Forsbergs now live in New Mexico and Howard has turned his talent to the Western genre and his paintings of frontier and Indian life are represented by noted galleries in the Southwest.

In all his artistic endeavors the challenge and excitement of painting the figure never ceased for Howard Forsberg. The how and why of his approach is spelled out in concise, step-by-step procedures leading to the finished picture. The results, a delight to behold, appear deceptively simple to achieve.

Contents

Acknowledgements

I want to thank Walt Reed for his encouragement and my wife, Jean, for her roles as art director, editor and typist in the preparation of the entire project. It would never have seen the printed page without them.

Introduction

There are three things of importance in any "how to" book: What it says to you, how it says it and how well you relate to the information. To fulfill these criteria I propose to lead you as an individual interested in painting the figure, through certain basics in a logical step-by-step manner. There are no hidden tricks, no slight of hand you won't understand. And it will work. Many years of experience as a participating professional and teacher have proven the validity of these principles. The approach is mine, the style is mine, but the knowledge is universal. It is a truth distilled from the accumulated knowledge acquired by untold generations of known and unknown artists, all of whom make up our Western art heritage.

These principles can help the beginner get started. They can help the experienced artist improve and become more aware. What each individual must bring to the study is the interest and desire to tackle the most fascinating and challenging subject any artist ever faced — the human form.

Art, and specifically painting, is not an absolute science. It is, fundamentally, a means of personal expression — the kind of expression that allows your emotions to interject themselves into each project you attempt. I don't subscribe to "intellectualizing" about art no matter what its form or media. Everyone "sees" things in his own way and will interpret and express those things personally. I urge you to be personal and make the most of *your* unique experience in your work. Remember, however, in the history of painting thousands of individual artists have contributed in some measure to the whole. Based on this heritage there are standards that must be understood and acknowledged. Some of these standards have been formulated into basic rules or suggestions. To achieve understanding and excellence then, you should learn these rules. After you have absorbed this knowledge you may wish to interpret the rules in your own way. You may even decide to discard or distort them. This is your prerogative. Painting and drawing are nothing more than decision making from start to finish. Making changes in sizes, color, values and proportions are part of the game you should be willing to play to accomplish the final result you desire.

The human figure is a beautiful work of nature. Its ability to compensate for its distribution of weight, the counter-balance, the opposing movements of its structure, its grace and symmetry are wonders to behold. After all the years I've spent in studying the figure, I'm still enchanted by slow motion film of a figure in action. It is a never ending marvel to see and study. The tension of one muscle as another relaxes, the arm flung up to oppose the weight of an opposite leg, the changes in overall silhouette, all combine to display the body as a beautiful and functional work of art.

I'll try to keep the instruction as simple and uncomplicated as possible. And, I'll try not to sound like a know-it-all. As a teacher, I've found that work showing years of experience and consummate facility can appear almost unattainable and be frustrating to the beginner. For this reason most of the examples will be simple and as unsophisticated as I can make them. Encouragement is what the artist feeds on and each step forward should have its own reward. The information is presented in easy stages, one step at a time. Approach your painting with a light heart and have fun, and remember, with each attempt you will have learned and absorbed some one thing. If this occurs for you — and it should — the premise of this book will be fulfilled.

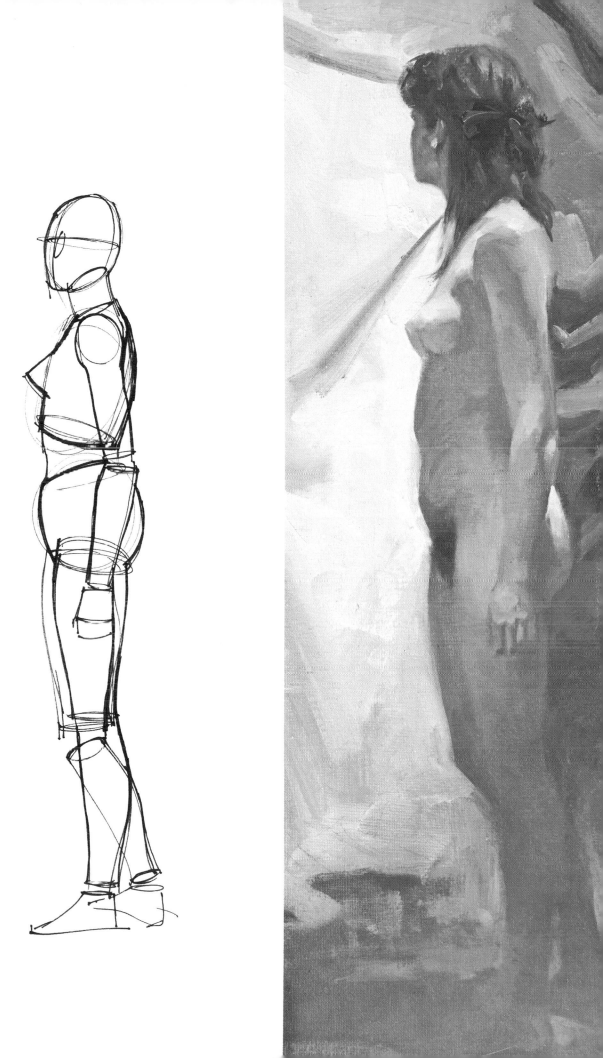

1 Materials and Tools

If you are an old hand in using oil paint and too set in your ways to change, you can skip this section. However, if you're not too sure about your procedures you would do well to read on along with the beginner.

All of the painting demonstrations for this book are in oil. They could be in any medium without violating any of the basic principles of figure painting. I choose to work in oil because I like it. For me it is the most satisfactory medium. You can mix it rapidly; apply it freely; work loosely or tight, thinly or thickly; wipe it out or paint over it for corrections. And the color doesn't change value when it dries. No other medium can do all these things. I recommend it to you as a particularly fine medium for figure painting.

As with everything else in art, there are no absolutes in how to use and care for your tools and equipment. These are my thoughts about what works for me.

It is interesting to reflect that the basic tools and equipment we use today have suffered little change since oil paint was first used some 500 years ago. Fortunately, the chemistry of paint making has advanced radically and today we enjoy the convenience of a wide variety of serviceable colors in tubes. I'm not sure I could have prevailed in being an artist if we still had to grind and compound our pigments.

Brushes, knives, palettes and paints are the tools. Simple things but they do require some thought and care. Through use they become the extension of your hand and brain. You should be so familiar with them that you use them as naturally as you write with a pencil. Take care of your tools so you won't have to fight them. Painting a picture is difficult enough without having to contend with bad brushes or half-dried paint.

Brushes

Of all the tools in oil painting, the most personal one is the brush. As an extension of your hand you can learn to control the bristles to move the paint around as if it were an especially formed finger. Brushes are available in a wonderful choice of sizes and styles. Because of the personal relationship that grows between an artist and his brushes, you will develop favorites which give you the quality and textures you like. My favorite for the initial drawing of a painting is a No. 2 bristle, quite worn down. It takes some time to get hair to the degree of shabbiness where the brush becomes a marvelous drawing instrument. I'm always sorry when one finally wears down to the pure metal and I have to replace it.

The various types of brushes used in oil painting are the regular hog's hair or bristle brush, the sable and the badger hair. The hog's hair comes in different styles, the flat, the bright and the filbert. These names distinguish each brush from the other by their length of hairs or bristles. I prefer the flat hog's hair brush because of its firmness and squared tip. The sable hair brush, in its smaller sizes, is quite helpful for detail work and the smoothing of various textures. The filbert has a long bristle and is somewhat rounded at the tip.

The No. 10, No. 6 and the No. 2 brushes along with the addition of the No. 4 and No. 2 in the sables and a fan shaped badger for blending would be adequate to begin your painting. As you proceed you will want to experiment with a variety of sizes. There are oil painting kits that can be obtained in art stores containing small palettes, small tubes of paint, small palette cups and several brushes. Trying a few of these sets might give you a feeling for the kind of brushes and equipment that best suit you. Quality brushes are expensive, so try to take good care of them. Reasonable care will prolong their life considerably. Rinse in turpentine after each use and then wash in mild soap and water and dry with a rag or paper toweling. This simple procedure, if done after each session, will keep your brushes in good shape for a long time.

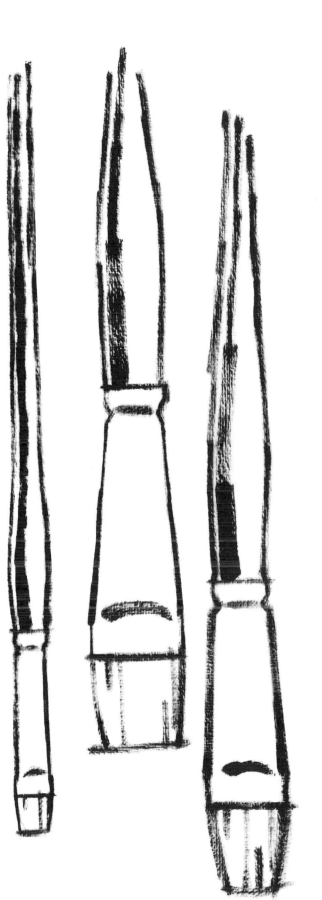

Knives

Painting knives can be bold and striking instruments when used judiciously. There are various sizes and shapes available to suit your needs. Painting knives are flexible, made with good steel and when handled carefully will last indefinitely. The hazard with the care of knives is that when dropped on the floor the blade or point may be bent. It's tough to get it back in shape when this happens. Don't confuse painting knives with palette knives which are quite rigid and suitable primarily for mixing paint or scraping your palette. I regularly use three or four painting knives that vary in size and shape. I also find useful a razor blade mounted into a holder. I use it instead of a palette knife to clean my ¼-inch thick glass palette.

The painting knife can give you bold effects, and it is a tremendous tool when used along with the brush as the different effects complement each other beautifully. Painting with a knife usually creates impasto or thicker paint. This paint texture gives the surface a dimension that is difficult to achieve in any other way. There are, of course, painters who paint with the knife only, but I prefer the greater variety in paint effects you can achieve by using a combination of tools.

14

Paints

There are many different brands of paint on the market today, and most are of good quality. They come in two standard size tubes — professional or studio size and the smaller student or academic size. I buy the larger or professional size and recommend you do the same. With the smaller tube you will have the tendency to squeeze out a smaller amount of paint, and by doing so you may be inhibited by your skimpy palette. Paint is relatively expensive, but don't let that consideration dictate your style.

Manufacturers offer a great variety of colors to choose from and all have their own particular names for the various shades and hues. I suggest you begin with a simple variety of colors: cadmium red, ultramarine blue, cadmium yellow light, violet, burnt umber, burnt sienna, alizarin crimson, naples yellow, viridian green and white. I use titanium white as it does not yellow with time. This will give you an ample palette. Later on, you can expand into the other colors you wish. You will find that the colors might vary with the different manufacturers. I have stayed with more or less one manufacturer and am never disappointed in a particular hue or color I receive. From the standpoint of permanence, we probably have to take the manufacturer's word for it. The question of color being "fugitive", that is, one that will fade in time in ordinary light can be a serious factor for the painter who is concerned about the lasting quality of his work. For student work and many commercial assignments such considerations are unimportant. However, you should be aware that even some of the most expensive paints in mauve and blue may fade some in time. Most other colors will retain their brilliance indefinitely.

If the caps on the tubes are difficult to open, heat the caps with a match to loosen them. There will be more on paint and paint handling later on in the color section.

Taboret

According to my French dictionary "tabouret" is defined as a high stool. That bit of information amazes me as I have always felt secure in the knowledge I knew what a taboret was. The addition of the 'u' apparently changes my multipurpose storage area, low table, palette holder into a piece of furniture with but a single function. Be that as it may, I am sure to continue to utilize my taboret for almost every purpose except to sit on.

Like most taborets mine is a simple, sturdy cabinet containing shelves and a drawer on top in which I keep my tubes of paint.

As you know, I use a glass palette and I keep a sheet of gray paper under it to help in seeing the colors I mix. The glass is easily cleaned with a razor blade even when the paint is dry. Many artists prefer a wooden or pressed poard palette. These are fine but they are a little harder to clean. The disposable, oil-treated paper palette pads are quite useful and I often use them when away from my regular studio set-up.

Every artist's studio is a reflection of his own personal tastes and work habits. Some are like museums, others spartan in their simplicity. My studio might appear to be cluttered and disorganized, but I have a feeling of oneness with it and know exactly where everything is located. It is my sanctuary.

The colors you will find on my palette are: titanium white, yellow ochre, naples yellow, cadmium yellow pale, cadmium orange, cadmium vermillion, alizarin crimson, viridian, ultramarine blue, cobalt blue, cobalt violet, burnt sienna, burnt umber.

And the tools: knives, brush containers, tubes of pigment, mahl stick, turpentine, paper towels, retouch varnish.

I rarely use the phthalo colors as they are rather intense and will dominate a mixture. Many artists use ivory black, however it has a tendency to rob colors of their brilliance. I prefer a mixture of ultramarine blue and burnt umber as a substitute for black. More on this when we get to the chapter on color.

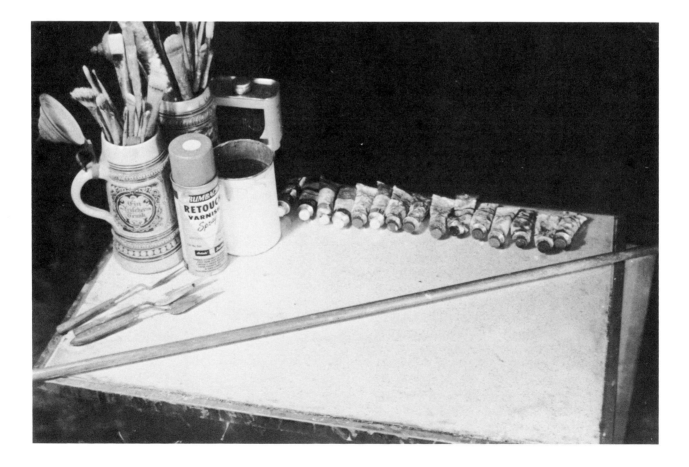

18

Painting Surface/Canvas

The choice and selection of a painting surface is a personal and arbitrary thing. With experience you learn the kind of surface you like best and the one that gives your type of painting the most satisfactory results. If you have a preference now, no doubt you'll continue to use it. Fine — no more need be said. If, however, you are not sure what to use I suggest you obtain mounted canvas panels. These are fairly reasonable in price and do not require stretching. If you learn to like the canvas surface you can stretch your own after you have experimented with the various types and textures.

A canvas panel can be covered with a coating of gesso or used just as it is when purchased. I often use an acrylic gesso on a stretched canvas or a canvas panel, and it works quite successfully. Apply gesso with a large brush so that some of the brush marks will be retained in the gesso surface. This creates a somewhat different texture that I like. The texture of the canvas under the layer of paint gives it a definite oil painting look.

Some art stores stock canvas textured paper, sometimes called canvaskin. This is an excellent, and fairly inexpensive surface for sketches and practice work. Many of the sketches in this book are done on it.

You can, of course, obtain canvas in rolls if you should wish to stretch it yourself. In stretching a canvas on a regular stretcher you will need a canvas gripper to hold the canvas as you pull it back over the strips. Also, you will need a staple machine or tacks to fasten each edge down as you grip it. This process can be discouraging in the beginning because the stretcher often gets out of plumb. You should check the results with a T square or you may end up painting on an obtuse picture area that no standard frame will fit.

Mediums

Turpentine of a good quality is probably the only medium you will need. It mixes well with the pigment and is used to clean your brushes. It dries fairly quickly. There are gels and oils available which you may wish to experiment with later as you progress. Linseed oil retards the drying of pigment somewhat but does keep the color glossy. Retouch varnish can be used as you work to restore color that has become flat and lusterless. A finish coat of damar varnish can be applied after the painting is completely cured in three to six months.

Mechanical Aids/Camera

Most artists will agree that in painting the figure, the best and most accurate way is to paint directly from life. The model is three dimensional and can be viewed from various angles. You can walk around the figure to get a better impression of depth and distance between various parts and the background. A feeling of air and space exists around the model. It's important to see this.

Sometimes it may be difficult to obtain models who will have the time available to spend many hours in one pose over a period of days. Photography can be a great help in alleviating this problem. The model in one visit is able to assume many poses and give you a wealth of reference material from which to work. As a substitute for reality photographs can serve the artist well. Keep in mind, however, the camera has no brain nor any knowledge or feeling of what it records. You must interpret what the camera perceives to give it life, feeling and meaning. There was a time when the

use of the camera by artists was held in ridicule. This has changed since it has become known that Leonardo da Vinci used the camera obscura; Jan Vermeer, the great Dutch master, and others used similar primitive forms of mechanical aids. Edgar Degas, the French painter, and some of his contemporaries were also known to have used photography. Such eminence has given a degree of respectability to the present day artist who use the camera as a helpful tool.

There are many different cameras available. I have a Pentax 35 MM with a good lens which I use for color slides as well as prints. I also have a Polaroid which I use for fast checking of a model's position or lighting. It is highly beneficial in setting up and deciding a pose before making a permanent photograph. One of the pitfalls in photography is color. Transparencies and prints can be quite misleading. It takes experience and a good memory to interpret the colors and values in the

photograph. One of the problems is caused because the light meter (built in or otherwise) reacts to a very light area and as a result the darker values are appreciably reduced. The eye sees an area has a certain brightness. We also see into the deeper areas where the contrast is not as great as the photograph indicates. It's best to have some experience in painting from life before using the photograph too religiously. Once you realize the limitation of photographs they can be helpful.

For the use of the slides I have a small projector and viewer in my studio that gives me an image surface of about ten inches square. The image is bright enough to be quite visible in daylight.

Other mechanical aids for the projection or adaptation of reference material include: the bell-optican, artograph, "lucy" and the pantagraph. All have been around for years and are useful aids.

Years ago as an apprentice in an art studio, I became aware many illustrators use a small hand mirror to view their drawings in reverse. I found this is an excellent way to check errors in drawing and values. It gives you a fresh view of your work. It is always difficult to appraise your painting with a "fresh eye." You become accustomed to errors or mistakes and from a normal viewpoint the eye accepts them. It is also helpful if you can manage it, to mount a large wall mirror directly behind your working area. By looking into the mirror you greatly increase your distance from your work and gain a different perspective of it.

Another item you'll find useful is the mahl stick to support your hand when working on small areas. Mine is about thirty-six inches long with a ball on one end.

3 Drawing the Figure

The human figure is an amazingly complex mechanism. Our ability to twist, turn and assume varied positions while automatically remaining in balance through a labryinth of unseen muscle adjustments boggles the mind — when we think about it. Usually we don't think about it. We take it all for granted as commonplace and normal. The only time we will give it a second thought is when we have some physical impairment or we want to draw the figure. I think it is true we never really come to know anything thoroughly until we try to draw it. Certainly, anyone who has seriously tried to draw the figure has come face to face with the miracle of it.

Every experienced artist I know approaches drawing the figure with respect and a kind of awe. It is understandable if the beginner experiences some despair and confusion. No doubt, Leonardo had this in mind when he drafted his set of proportions for the basic figure.

I find the basic figure extremely helpful to analyze the complexities of the body. Using the simple, basic forms allows me to construct the pose, establish the feeling of bulk and control the foreshortening with relative ease even for the most difficult action. Of course, the basic figure is not an end in itself. It is a tool, a foundation upon which a convincing figure can be built.

Our purpose here is to break apart the complex mass of the body and separate it into various distinct units so that each section can be more easily understood. As separate units with recognizable characteristics they can be managed. Then the units can be joined together to create a simplified human figure. The use of the basic figure will be helpful in giving you an idea of the figure's proportion, the size of the head in relation to the torso and so on. And it's an aid in learning to *think* about the figure.

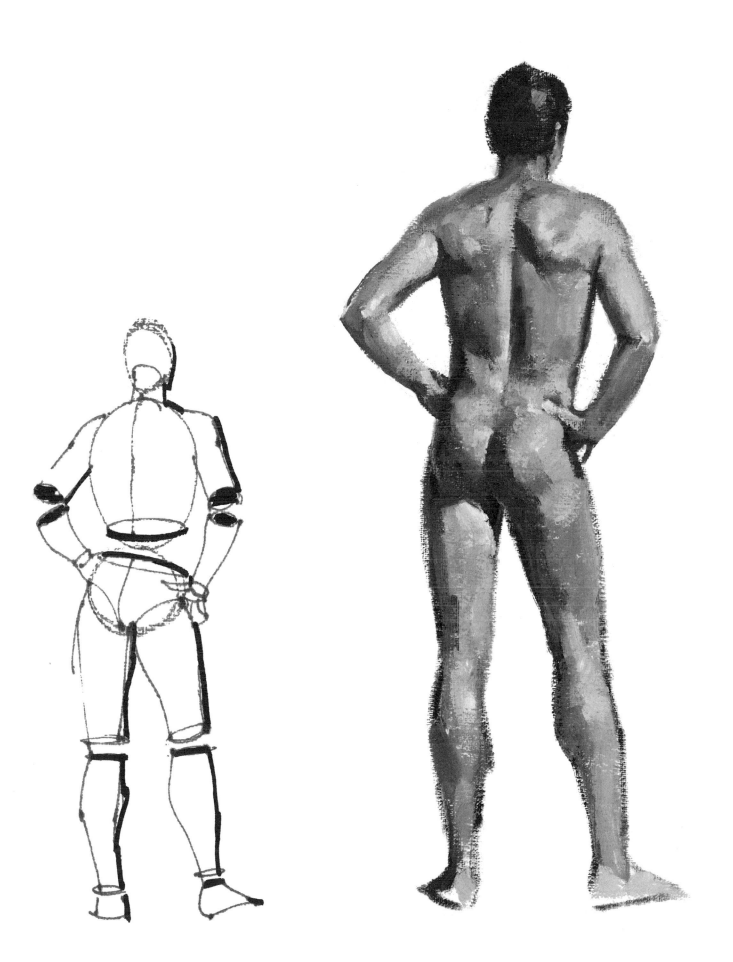

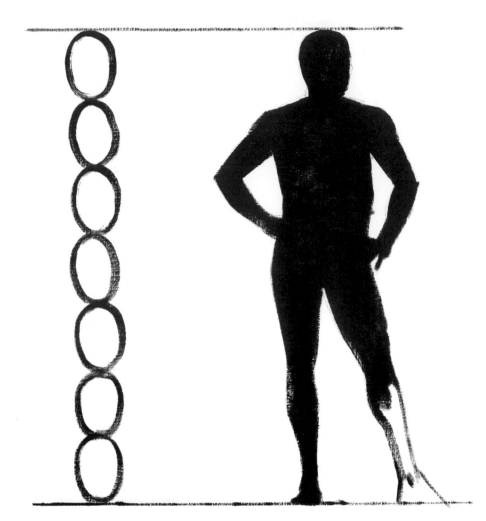

Seven Head Figure

Like da Vinci, we'll use the size of the head as the common denominator for determining the proportions of the figure, as well as the sizes of its parts. There are, of course, in real life many people whose proportions vary greatly from these standards. Some of us have large heads and short bodies. Others have small heads and long legs. The human condition allows for a great variety. What we shoot for is an average look, bearing in mind there are many exceptions to it.

The diagram on this page shows the seven-head figure. In other words, the size of the figure is composed of seven head sizes from top to bottom. This is a relatively average proportion in the male figure. In a photograph we accept readily this figure as being in good proportion, however to the artist it has the appearance of being a little too short and stunted. For this reason many of us prefer the slightly more idealized eight head figure as shown on the facing page.

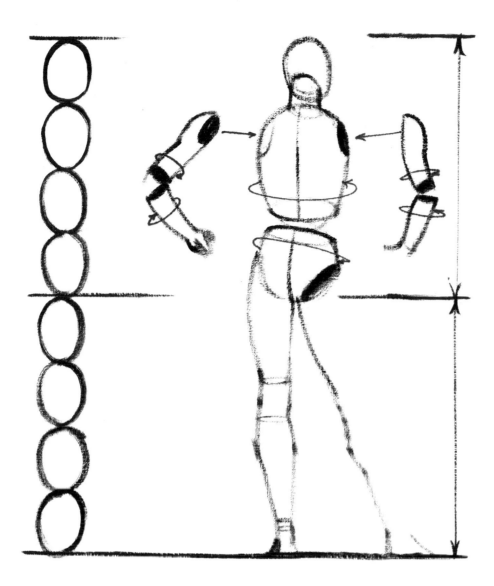

Eight Head Figure

The eight head figure gives a more classic and elegant appearance for a painting. This taste and thinking is exemplified in most fashion figures drawn today. In many cases they are ten or more heads tall! This gives them a chic look and allows the clothes to be given a svelte quality. The added size in the eight-head figure is considered in all parts of the figure. The legs and arms are longer and the crotch is at midpoint of the body with four heads to the top of the head and four to the feet. The idea is to make the figure taller without adding more width or bulk. It is not necessary to use a tape measure or ruler to accurately establish the sizes of the different parts of the body. If it appears right as you look at it, it is right. In the diagram the arms have been detached as separate units to show how they are joined to the torso.

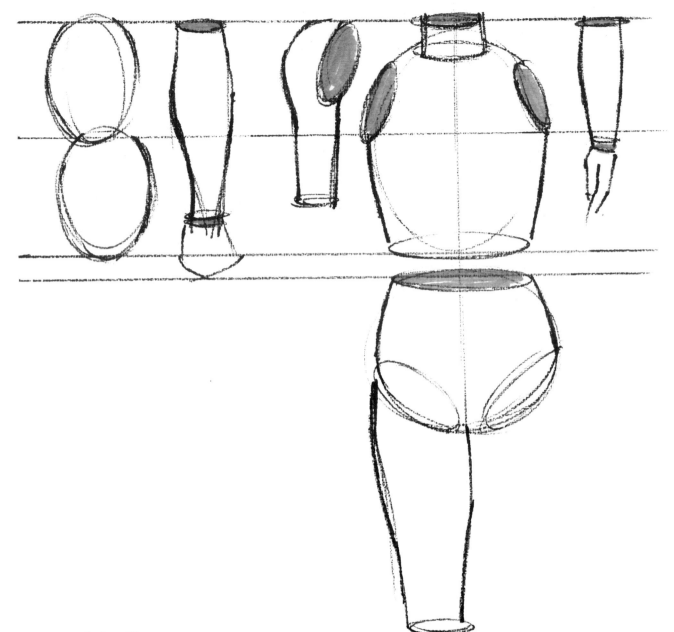

Parts of the Figure

The individual parts of the figure are shown here as separate units based on the head as the gauge to size. You will note that the lower leg in the first diagram is about two heads in length from knee to heel, whereas the upper arm is about a head and a half in length. The torso is a full two heads long and is generally about two heads wide. The forearm and hand are just a bit shorter than the length of the torso. The pelvic or hip section is about one head in length and the thigh or upper leg reaches the length of about two heads. Study these individual parts and see how they compare to the eight-head figure on the previous page.

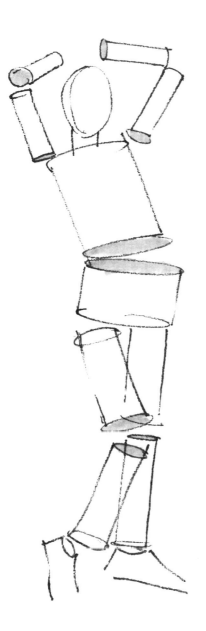
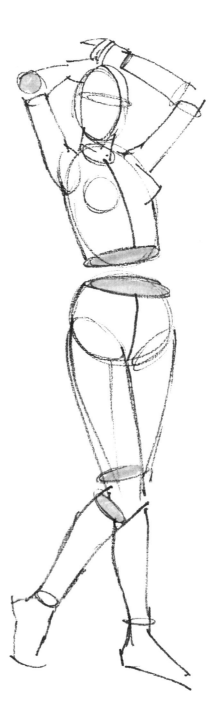

Modifying the Cylinders

Here we compare two ways of visualizing the simplified figure. One shows the simple tubular forms to describe the basic shape and bulk of the various cylindrical parts of the figure and how they fit together. The other figure has been more refined into the basic form shapes. This two stage process may be necessary at the beginning, but with a little practice, you will soon learn to skip the first stage. The important thing is to study both steps and be sure you understand how the modifications of the second step are based on the first.

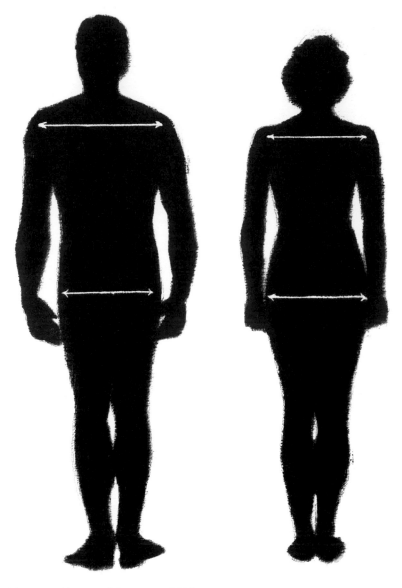

Proportions: Man and Woman

In studying the diagram above you can see the man's shoulders in proportion to his height are wider than the woman's. This is typical in the male and female figures. The pelvic area on the male, however, is narrower than the shoulders, whereas in the female the pelvic width is about the same as the shoulders. There is a marked difference in the thickness of the waist; the male figure has a larger waist than the female. Also, you will note there is a sharper curve in the hips of the female as opposed to the male. The woman's shoulders slope away from the neck more than do the man's. Also, the size of the woman's arms are thinner and the hands and feet smaller in relation to the overall size of the figure.

The diagram of the figure within the square shows how the height of the average man is the same distance as the span of his arms and hands. In almost every case this comparison is typical no matter how tall or short the individual may be. Keep this fact in mind to prevent painting or drawing the arms of your figure too short or long for the body.

At this stage we are mainly interested in the simple basic forms of the figure. However, it is important to have some knowledge of the anatomical structure of the body. Here are diagrams of the male figure's primary muscles and bones. The muscles and bones are about the same in the female but they are less prominent, and as a result,

harder to study. There are many excellent books on human anatomy available and the more knowledge you acquire on this subject, the better understanding of the figure you will have. Keep in mind, however, that as an artist your main concern is the way things look on the surface. Knowing what lies underneath helps but the details of the how and why of bones and muscle can be left to the physician.

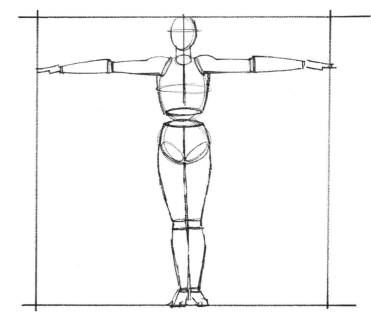

List of Muscles and Bones

1 – skull
2 – clavicle
3 – scapula
4 – sternum
5 – humerus
6 – thorax
7 – spine

8 – pelvis
9 – radius
10 – sacrum
11 – great trochanter
12 – ulna
13 – femur
14 – tibia

15 – fibula
16 – sterno-mastoid
17 – pectoralis-major
18 – biceps
19 – serratus magnus
20 – rectus abdominus
21 – supinator longus
22 – pronator teres
23 – external oblique
24 – gluteus medius
25 – sartorius
26 – rectus femoris
27 – vastus externus
28 – vastus internus
29 – patella
30 – soleus
31 – gastrocnemius
32 – tibialis anticus
33 – soleus
34 – peroneus longus
35 – deltoid
36 – trapezius
37 – triceps
38 – latissimus dorsi
39 – supinator longus
40 – extensor carpi ulinaris
41 – gluteus medius
42 – gluteus maximus
43 – semitendinosus
44 – biceps femoris
45 – sartorius
46 – gastrocnemius
47 – soleus
48 – tendon of achilles
49 – peroneus longus

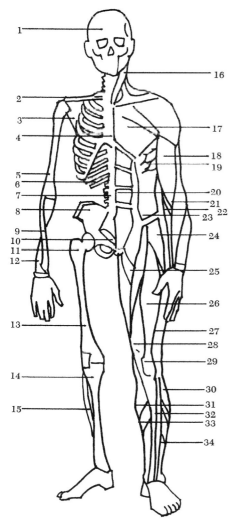

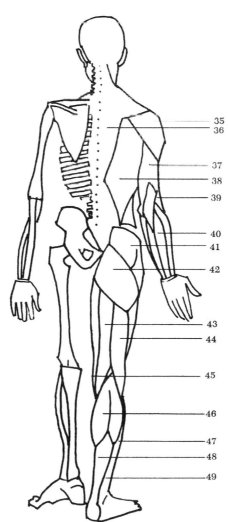

29

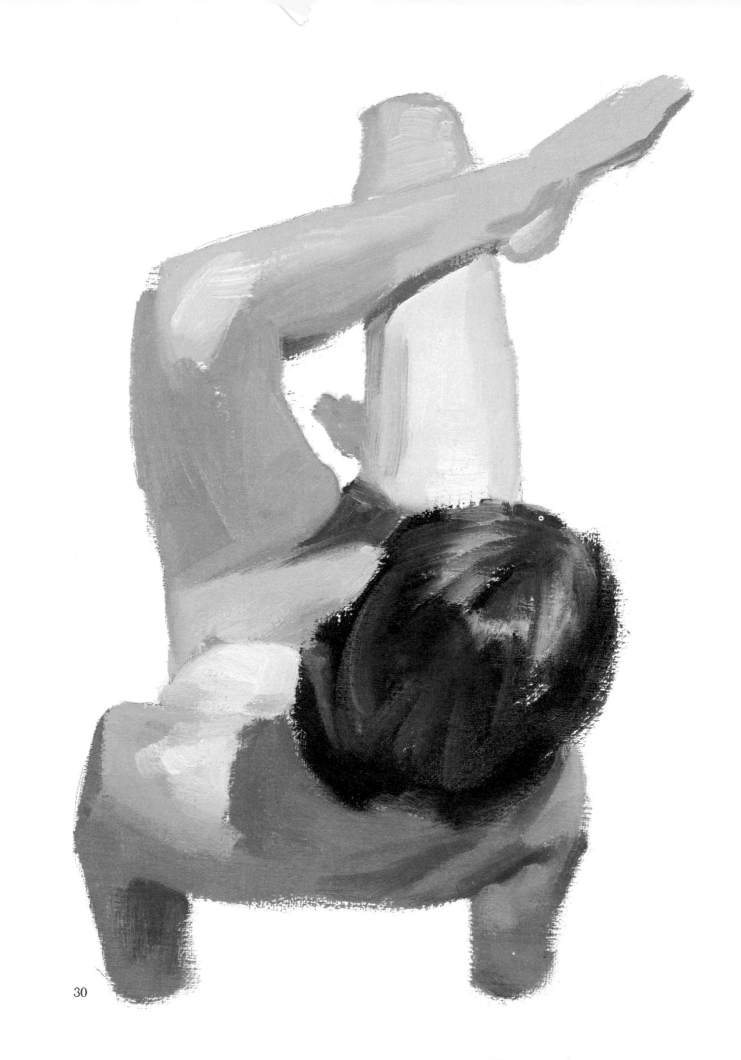

Foreshortening

There are few things more disturbing in a painting than when an arm or leg appears too long or the figure looks unreal or distorted because of improper foreshortening. How to foreshorten correctly is an important study in itself. The diagram shows the construction of the painted figure. Note how the arms appear short because of their extreme foreshortening and how the left thigh is shorter as it comes toward you. The tubular forms with the cutaway views give you a graphic example of the principle of foreshortening. The ellipses are rounder and tubes shorter as the form is turned towards or away from you. When drawing the basic figure it is best to show and indicate the portion of the figure that may be hidden. This is called "drawing through." I find this procedure helpful for it forces me to solve the drawing problem and fixes in my mind the correct position of all parts of the figure.

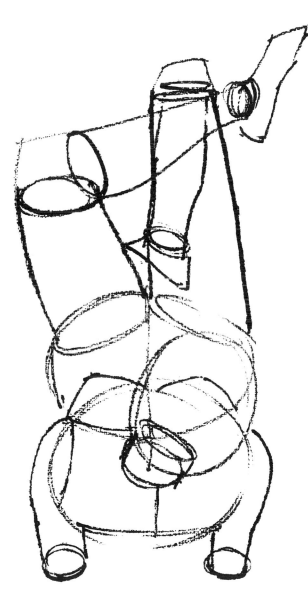

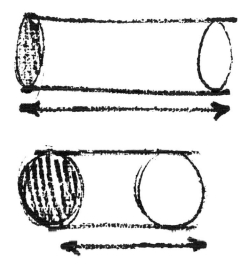

An Exercise in Three Steps

We will get into an extended study of values and modeling in subsequent chapters, but at this time I want to stress a simple approach with three tones in developing a painting of the figure. Do this exercise yourself using these sketches as reference. On the facing page is the first step. I have mentioned before I like to begin my painting and drawing with a well worn No. 2 brush. First I draw the basic forms of the figure. Then, as I am drawing, I indicate the shadows in a very simple way just to bring out the planes of light and shadows. The drawing is done quite loosely. Try to think in terms of painting as you draw and in terms of drawing as you paint. Any mistakes in drawing that occur can be corrected later in the painting procedure. The values used here are just a simple black for the hair and a deep gray for the shadow areas. Now, try the next step on page 36.

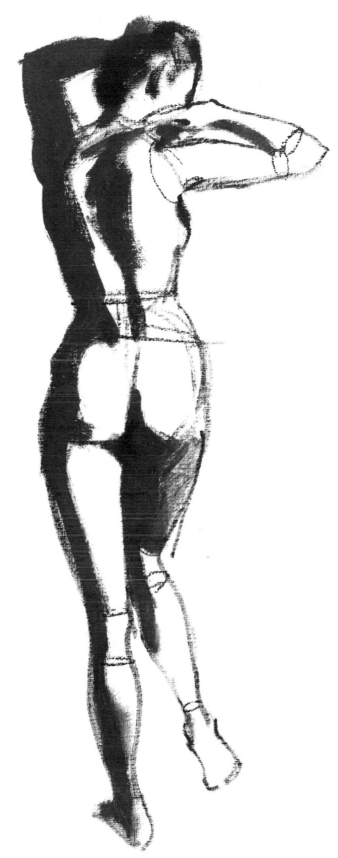

Step 1

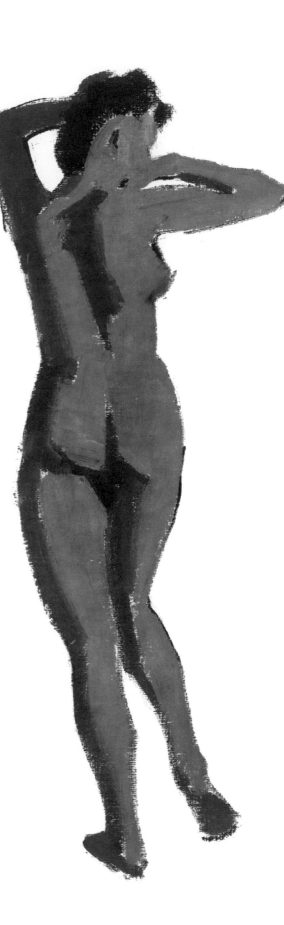

Step 2

By taking the previously mixed deep gray and adding a bit of white, you will develop a slightly lighter value, more of a middle tone. Using this tone, I completely cover the section in light that was left unpainted in the first step. Now a complete figure is beginning to take form and the feeling of some dimension is starting to emerge.

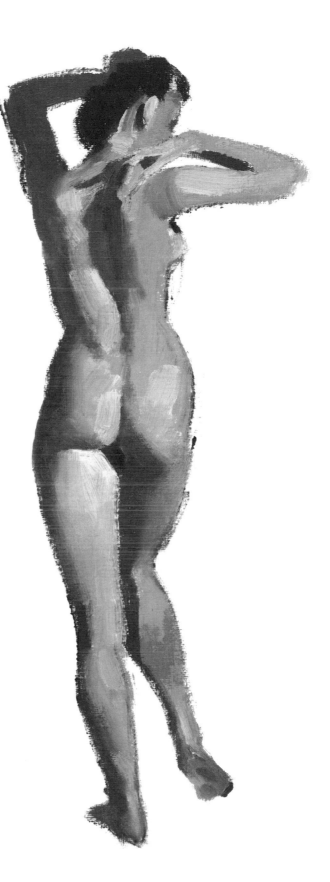

Step 3

Here we have a simple two-value figure with black as the deepest accent in the hair. While the grays are still wet, we'll add some white to the middle tone and mix it on the palette. Now, studying the model closely we look for the lightest area. This appears on the figure as the area on the inner thigh below the left buttock. There is another accent of light along the left part of the shadow that follows the curve of the spine on the lower back. There is also an indication of light along the left buttock. The figure now begins to take on a stronger quality of depth, roundness, and form. Look, again, closely at the model and note the highlights on the right buttock are slightly deeper than the other highlights. Go over the figure this way very simply. What we are striving for is a quick statement of values to show form. No labored refinements yet. We'll come to that later when we start considering hard and soft edges.

4 Figure in Motion

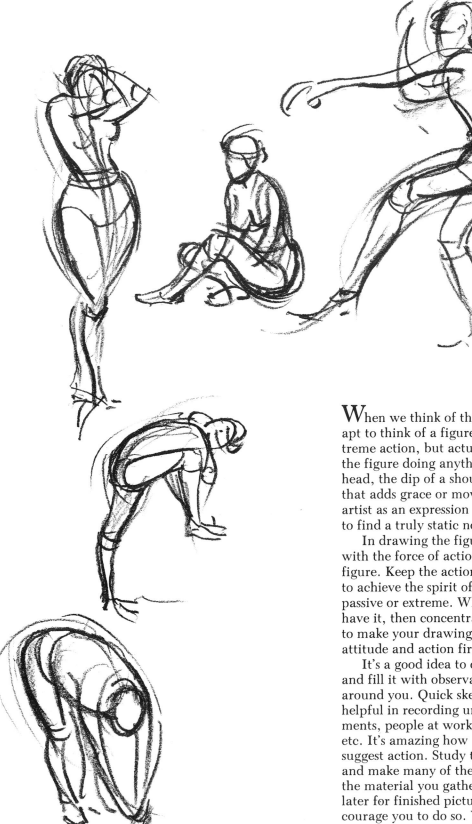

When we think of the figure in motion, we are apt to think of a figure jumping or running in extreme action, but actually the figure in motion is the figure doing anything. A gesture, the tilt of the head, the dip of a shoulder . . . any movement that adds grace or movement can be used by the artist as an expression of life. Indeed, it is difficult to find a truly static non-action pose.

In drawing the figure we are more concerned with the force of action than in the details of the figure. Keep the action simple and look for and try to achieve the spirit of that action whether it be passive or extreme. When you feel confident you have it, then concentrate on the details necessary to make your drawing complete. Keep in mind attitude and action first, then details.

It's a good idea to carry a sketchbook with you and fill it with observations of the people you see around you. Quick sketches and notes can be most helpful in recording unusual gestures or movements, people at work, children on a playground, etc. It's amazing how a few lines with a pencil can suggest action. Study the usual and the unusual and make many of these small sketches. Much of the material you gather in sketches can be used later for finished pictures and paintings. I encourage you to do so. You will find it rewarding.

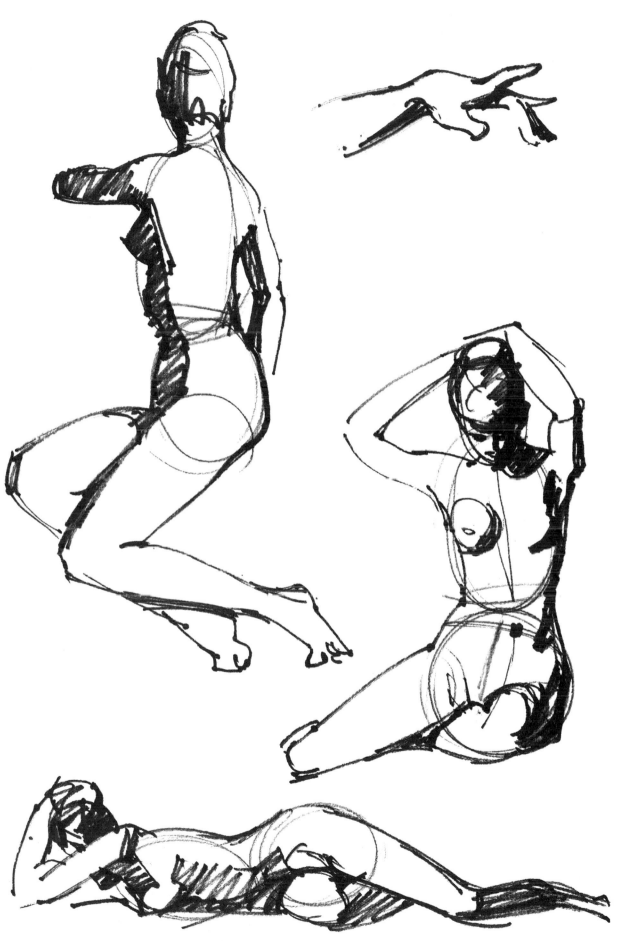

39

On the opposite page is the basic form drawing of the figure on page 85. Notice the strong action in the opposite swing of the hips and shoulders. Here, again, the pose would be difficult to control without using the basic figure. By forcing yourself to analyze the foreshortened forms you gain a better understanding of the action and subtle movements in the figure. "Drawing through" helps to establish the solidity and roundness to the forms to enhance this graceful pose.

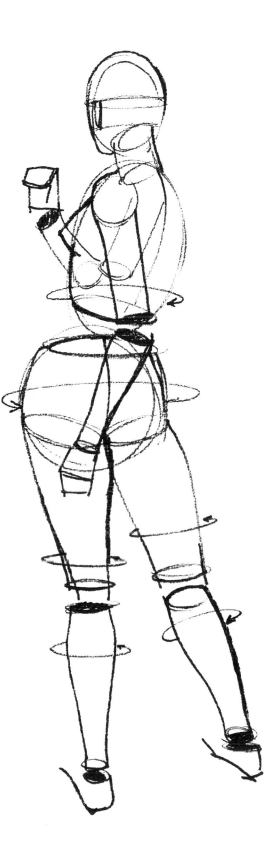

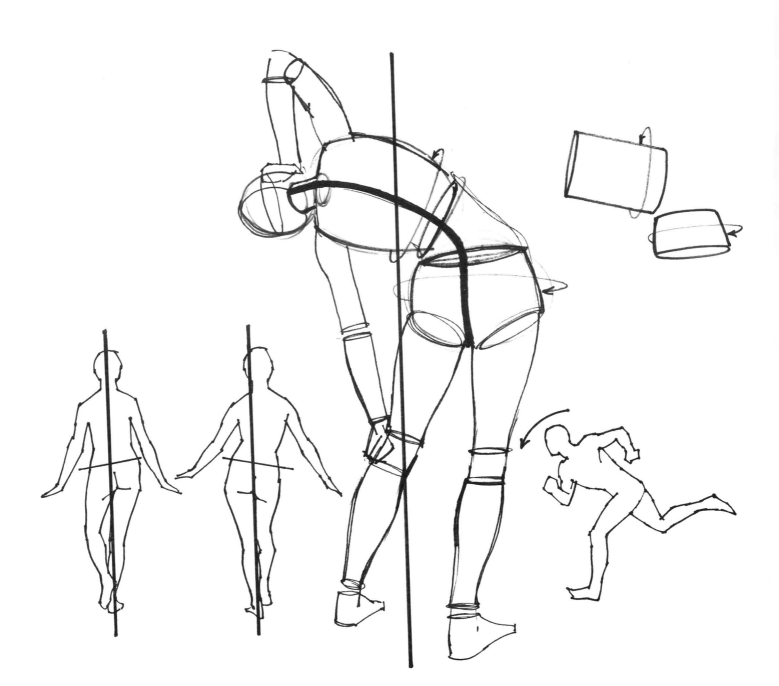

Drawing the Figure in Balance

Balance is of cardinal importance to the human condition. When things are out of balance we are disturbed because, consciously or unconsciously, we know there is danger. Something is going to fall. When we draw the figure and wish to project a pleasant, tranquil response we must be sure the pose appears in balance. Conversely, when our plan is to express violent action having an uncertain result we would draw the figure out of

balance and consequently out of control.

Illustrating the figure in motion always presents problems if you are dealing with any kind of realism. Your job as the artist is to capture that fleeting instant when the action is stopped. No matter how violent the movement the figure can seem safe and under control if our eye says he is in balance. Arriving at that condition sometimes requires a lot of exploring and experimenting to find the most descriptive action. Again, the basic figure is a most helpful tool. Also, it is good practice to learn to use and understand the balance line.

After you have experimented, explored and have decided upon the instant of action you wish to draw, indicate lightly a vertical line which I call the "line of balance." The position of this line usually can be established by visually determining an equal division of bulk on either side of a perpendicular drawn through the figure to the ground plane. It is a kind of visual scale. As you can see in the diagram of the large figure, the line of balance goes up through the left knee to the left of the hips and up through the chest. If the figure did not have the left hand on the left knee, and it was flung out away from her, the line of balance would have to change. However, in this case the left arm is helping to support the torso and head so the line of balance seems about correct as drawn. Note, too, how the curve of the spine follows the position of the torso and the hips. The spine and the body

move together, so always look for and study the curve of the spinal column, as well as the slant of the shoulder and hips. The rotation and turning of the torso is due to the twisting capability of the vertebrae that make up the spinal column.

The smaller figures at the left indicate how the buttocks shift from right to left of the center line in the motion of walking. The hips move up and down at a slant depending on which leg is up or down. There is a difference, too, in the position of the shoulders relative to the line of balance.

The running figure looks in balance at the instant his motion was stopped. Bear in mind, however, a walking or running figure is actually throwing himself out of balance with each stride. For instance, an individual walking forward steps on one foot, then throws himself forward out of balance, catching himself with the opposite foot as it is put forward. In this way he is able to move from one point to another. In running, the action is exaggerated so the figure gains greater speed. Of course, in running and walking, the legs and arms work in opposite, reciprocal motion on each side to maintain balance as the body leans forward. Both actions — indeed most action — creates a constant change from balance to imbalance, but the shift is hardly perceptible. As a result we see almost all human action as flowing, balanced movement.

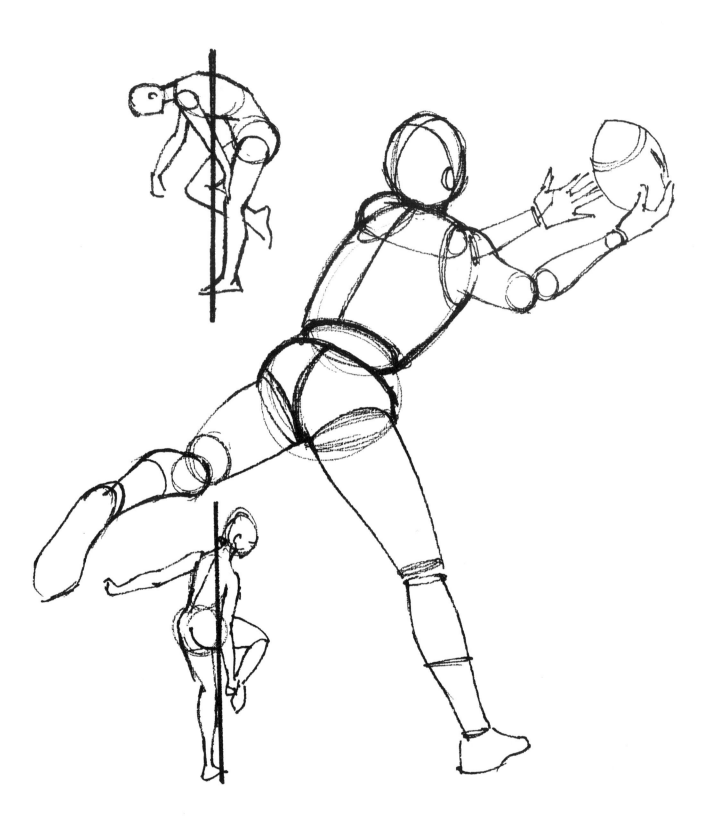

44

In the small illustrations of the figures standing on one leg, study how the weight is distributed in relation to the balance line. You will note in the upper figure that the head and shoulders are extended to the left of the line of balance as the figure bends over. The arm is flung forward to create more weight on that side to allow the figure to continue to stand. The point of balance is the foot of the figure, and as he supports himself, he leans slightly back so that his hips are not directly above his feet. Then, as a counterbalance, he bends his right leg at the knee and projects it forward. The lower sketch describes this same type of action but the figure is more erect. Note the flung out arm. The head and part of the torso are to one side of the line of balance, but a good deal of the figure is to the left so equilibrium is maintained.

In the larger drawing the running motion causes the figure to lean forward at the hips, while stretching out his left leg to the rear, as the arms reach outward. The figure is out of balance but we feel he will catch himself as the left leg moves forward. Using basic forms helps a good deal in the construction and foreshortening of such actions.

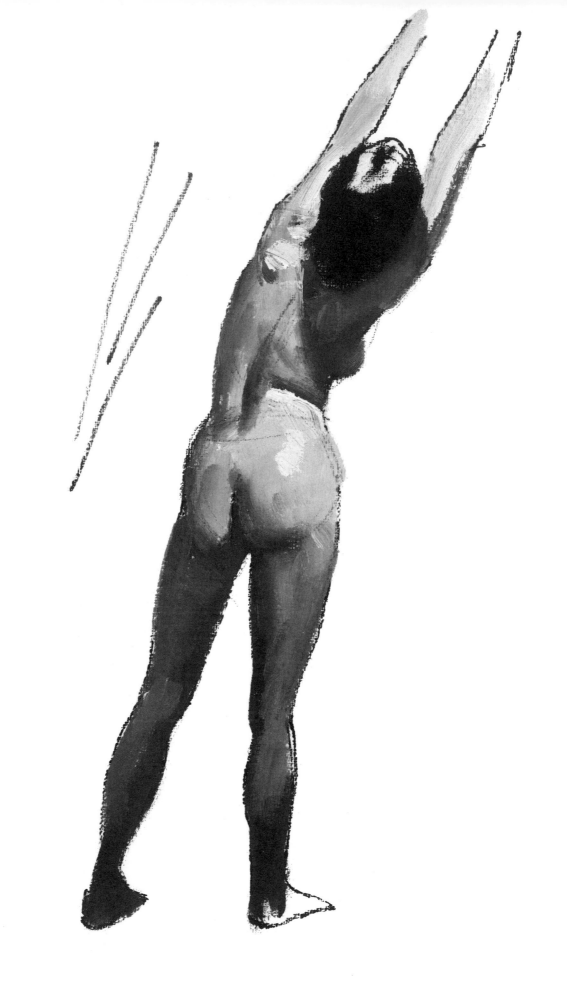

46

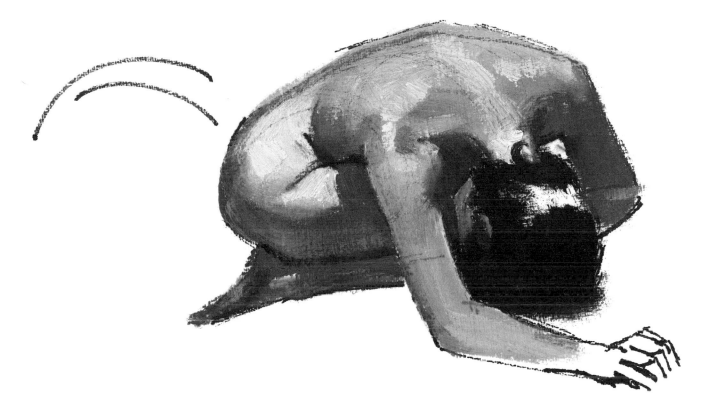

Mood

To one degree or another all of us are sensitive
to variations in human expression. We know or
imagine we do, what a person feels or thinks when
we look into his eyes. More than that, we know
from a gesture, the tilt of a head, the slope of the
shoulders something of that person's attitude and
feelings at a given moment. Few of us possess the
grace of ballet dancers to express our body
language but all of us use subtle adjustments in
pose and physical attitude to project our thoughts.
Because it is so expressive, paintings of the figure
can convey a mood with acute effectiveness.

The illustrations here were done to express
through pose alone, two opposite moods: ex-
uberance and despair. Symbolically exuberance or
joy is translated into vertical, thrusting lines, while
despair or sorrow is described by downward curv-
ing lines. The figure is capable of so many descrip-
tive expressions that a subtle lifting of an arm or
bowing of the head can change an attitude from
one mood to something completely different. All
artists throughout history have used the figure to
project mood. The action of the figure is a major
way of achieving this. Color choice, value and
location have a great deal to do with the mood,
but the pose of the figure is most important.

Think up some mood symbols of your own such
as peaceful (rhythmic horizontal lines) and conflict
(jagged crossing lines). Then try to draw poses that
carry out the mood.

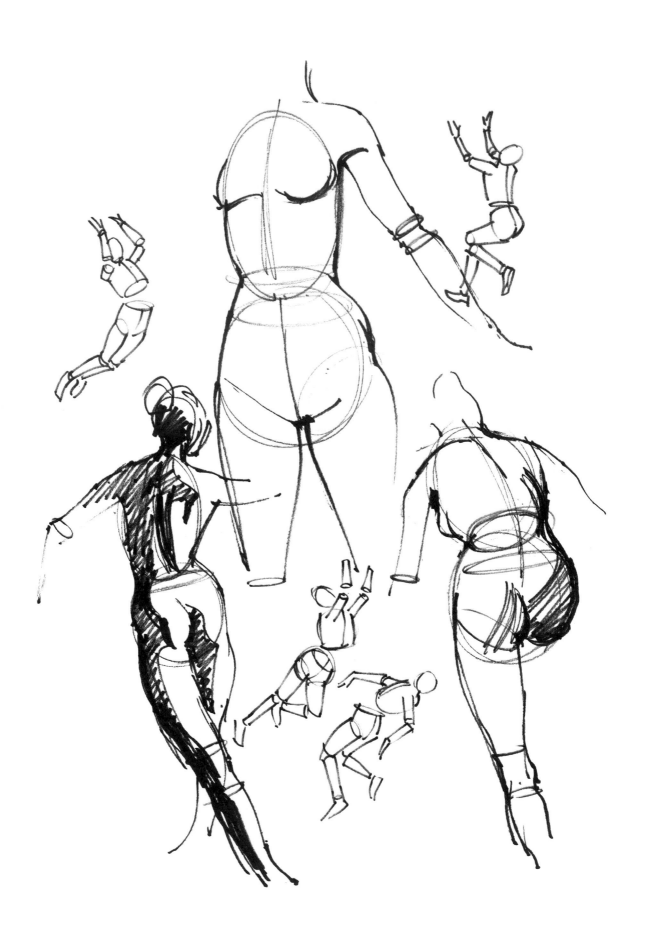

Practice making quick sketches of the action of people around you. Use the basic forms in these small quick sketches, developing the action as you draw. Try to become as familiar as possible with simple forms until they are second nature to you.

Silhouette

As you study your model either directly or from photographs, make a few quick sketches of just the silhouette of the pose. This will help you to see the action and the overall contour of the figure. It'll aid you in establishing good balance and in creating a convincing action. The example here shows the curving rhythm of the pose which is apparent in the tonal figure as well. Using a strong light coming from the right of the figure makes for a forceful value pattern that adds dimension and enhances the feeling of grace to the pose. As you can see, the silhouette sketch is not elaborate. It is simply a device to help you to determine the overall contours, proportions, balance and believability of the pose.

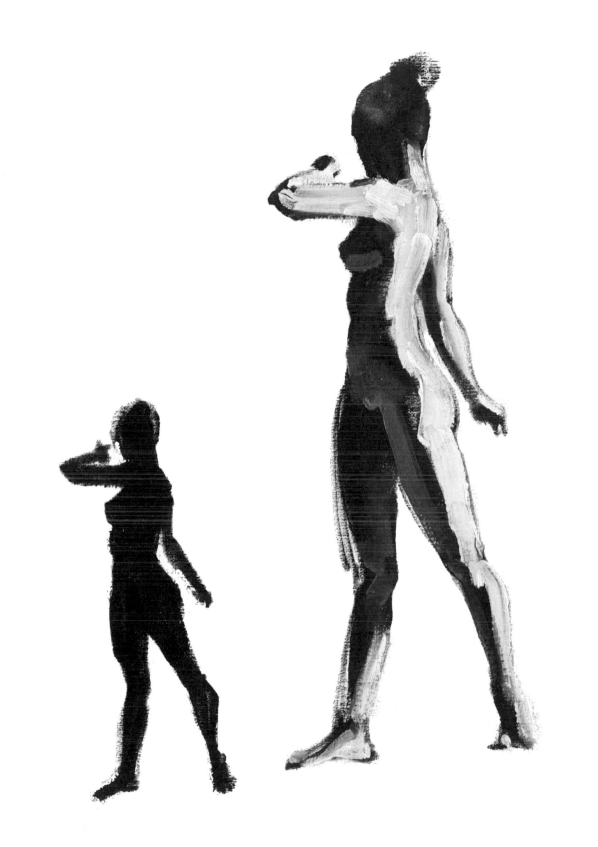

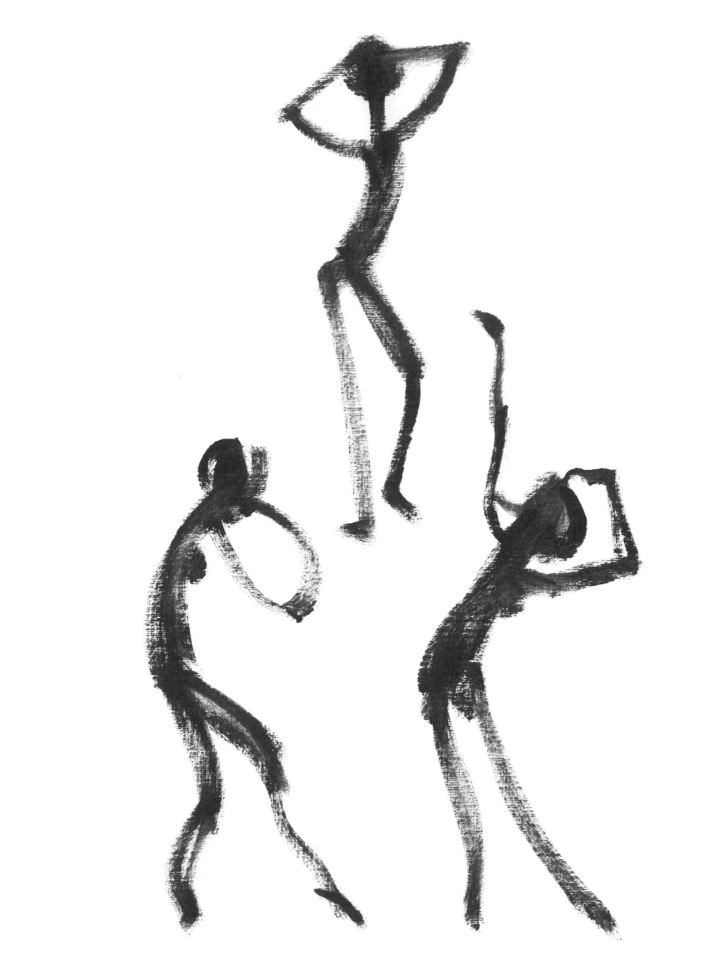

Gesture

At the outset of any drawing I like to establish
the movement in the entire figure. This can best be
done with fast, simple gesture sketches. The idea is
to get on paper spontaneous lines that express
visually what the figure is doing. The examples on
the opposite page will give you an idea of what I
mean. Such gesture drawings should be done in a
few seconds — don't even think about details.
Focus your total attention on capturing the feeling
of the action.

I find it helpful when doing gesture drawings
with a brush to hold the handle near the end and
swing it like a saber. Try it. Extend your arm at
the shoulder using free and easy strokes with the
brush. Small gesture figures are a good way to
begin the painting of a particular pose.

Passive Force

Here is an example of a quick sketch to develop pose and lighting ideas. Many artists make such sketches prior to posing the model.

The action of this figure portrays a certain passive quality, but at the same time, has strength and force because of the opposite twist of the shoulder and hips.

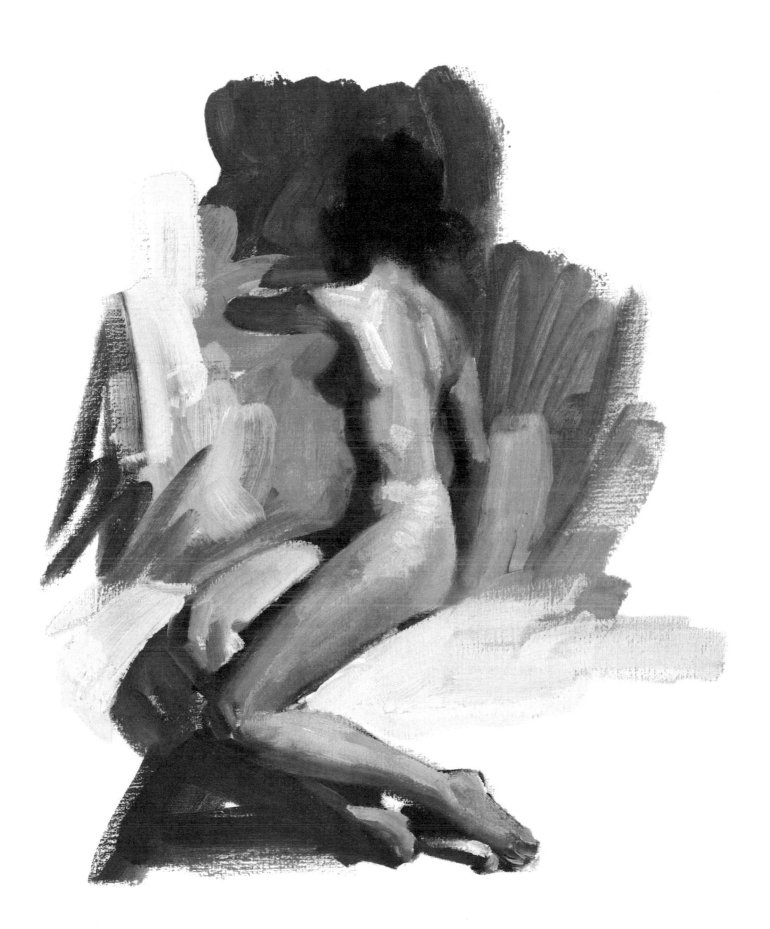

Simplicity

Work only for large simple areas for strong design. Try for interesting shapes, both positive and negative.

This sketch was done by first toning a portion of the canvas with a pale gray mixture of thinned paint. Toning the background allows you to see your values more clearly. Working against pure white can sometimes throw you off. When the toning is more or less dry then the regular procedure of drawing follows using the basic forms. Note that the hair blends into the background area as do many of the tones on the figure. Such blending helps to create a simple and interesting overall design and establishes the figure in an environment. The highlights are developed in the same way as in the figure painting on page 37, by injecting the lighter values into the middle tones to create the impression of roundness and dimension.

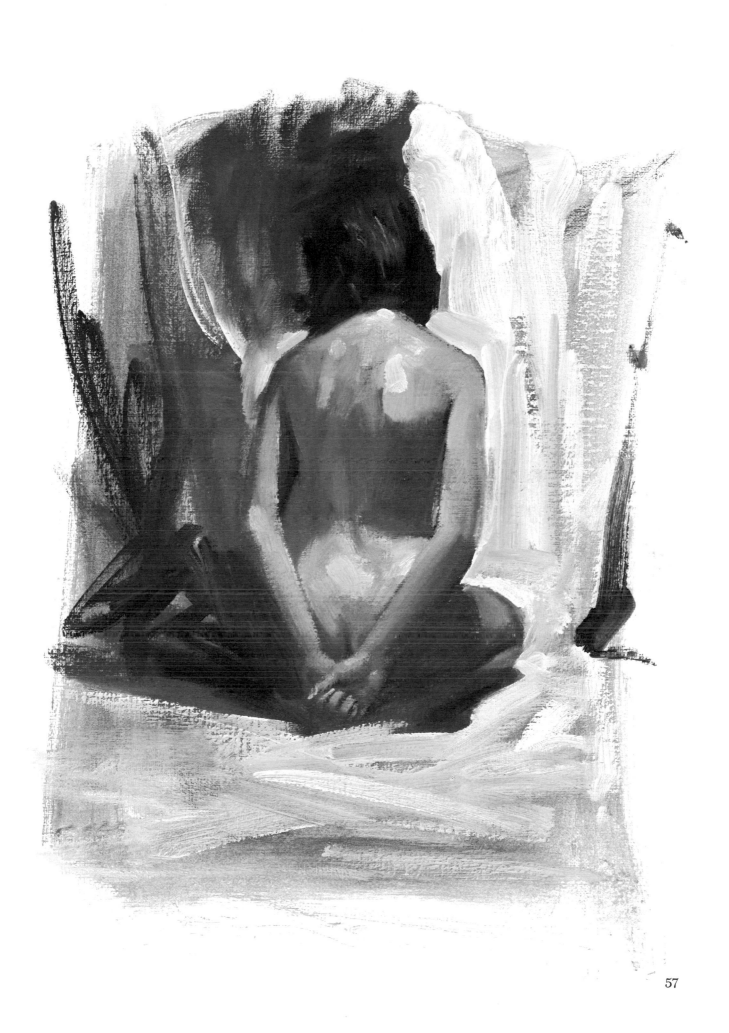

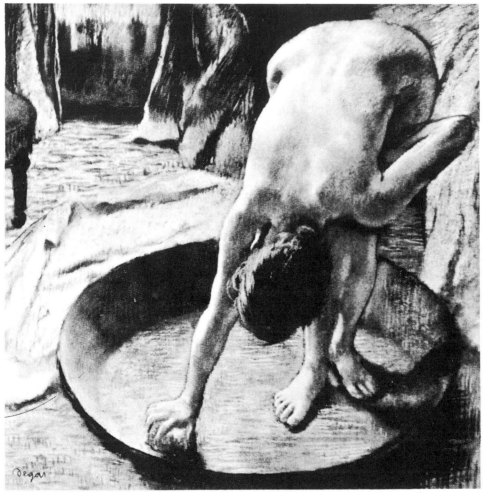

Edgar Degas
Woman in the Bath-Tub
Pastel

Edgar Degas' painting on the facing page contains many of the points covered in this chapter. It is a fine example of simplicity in concept and approach, having a naturalness I find compelling. The absence of self-conscious "cuteness" lends realism and honesty to the action of the figure. The mood is interpreted fully by the directness and concentration of what she is doing. We feel the subject's sense of privacy and well-being conveying an attitude of quiet content.

The excellence of the drawing is displayed in the back and hip sections, with sensitivity in the movement of the arms. One arm is back to offset the weight of the other as it is extended forward to help maintain support and balance.

The basic form drawing characterizes the figure as it would appear viewed from one side. The legs are slightly bent as the lower torso is moved back and lowered. The feet become a fulcrum with the body weight distributed almost evenly on each side. The chest is literally resting on the upper legs. We must admire the artist's mastery of anatomy to be able to translate this unusual pose into such a beautiful and simple statement.

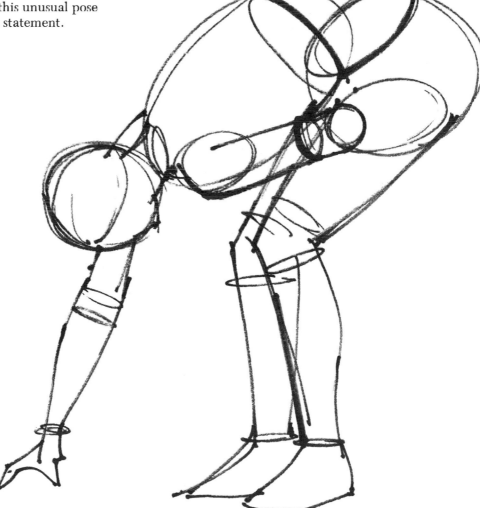

5 Values

relative thing. It relates to the area surrounding it and is directly influenced by the light source. If an object is struck by a light source coming from above, the top areas that are closest to the light will appear very light in value. The sides will be diminished in tone. And the farther the light travels from its source, the darker in value things will appear. Knowledge of these simple facts allows us to create the impression of roundness and dimension in painting.

Probably no other property is as important to good figure painting as being able to see and control values. In the figure there are an infinite number of subtle, intertwining areas that can only be defined through the use of correct values. If the values are wrong the figure will be unconvincing no matter how well all the other considerations are handled. The old trick of judging values through half-closed eyes is a good one. Squinting eliminates details and some of the subtleties so you can more easily determine just how light or dark an area is in relation to its surroundings.

On the next page are small squares of values ranging in eight steps from white down to black. This is about the limits of value separation you should strive for. We can, of course, distinguish many more value gradations than this between white and black. However, in painting, the six intermediate tones shown will be sufficient in most cases to convincingly represent any painting you will undertake.

Keep in mind that our white paint is much deeper in value than many things we see in sunlight. For instance: a highlight on a strip of chromium or the reflection off a window. In order to create this kind of an illusion we must make the relative values around the white paint deeper by contrast. One of the most important words that we should remember in the study of values is "relationship." Each value we paint need not accurately duplicate the value we see. But the overall relationship of one value to another in our picture must be correct. In short, like everything we paint, we must interpret the values we use so that they seem correct in the environment of our painting.

Notice that the white area inside the black border in the upper square appears to be whiter than the area inside the gray border below. This illusion should give you a good understanding of how important value relationship can be.

One of the most important things the artist must recognize and understand is value. Value means simply the lightness or darkness of an area. Under ordinary lighting conditions a light colored area will look light in value. If the light is reduced in intensity, or the area thrown into shadow, its degree of lightness will diminish and we say it is reduced in value. In other words, a white shirt in a bright light will look very light. In a dim light the same shirt will look more of a half-tone, and in shadow it could become quite dark. Value is a

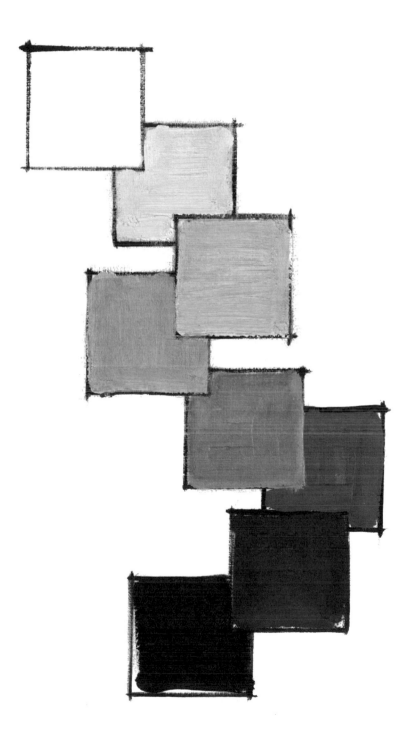
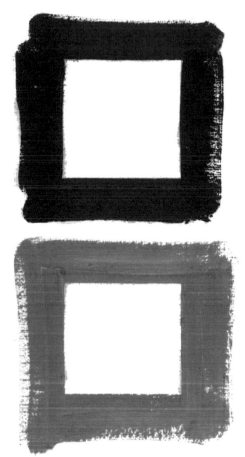

6 Modeling

The term modeling is used to describe the application of the paint in a variety of closely associated but different values to create the illusion of form and structure. An individual might be referred to as having a finely modeled face or well modeled head. This suggests that the various planes and surfaces of the face or head are delicately molded and curved, one into the other, probably in a pleasing fashion. To capture this three-dimensional quality on the two-dimensional surface of our canvas requires a certain amount of artistic legerdemain. The most important part of creating a successful three-dimensional illusion is proper control of the values. Other important factors are the treatment of edges, reflected lights, establishing planes, creating accents and the thick and thin quality of your paint.

To be sure we know where we stand let's go over each of these considerations in some detail.

Toning Canvas

I've already mentioned some things about toning your painting surface but because it is important to understand and to get off to a good start, I'd like to go into this procedure a bit more.

Like many artists I find a bare, white canvas terribly inhibiting. This alone, is sufficient reason for a quick toning job. The other important thing is to reduce the white to a middle tone so that I can work both up and down in applying values.

The first step is to take a mixture of burnt sienna and ultramarine blue mixed quite thinly with turpentine and using a large brush or tissue, apply the mixture over all or most of the canvas. Keep the mixture thin so that it goes on easily. Because there is little pigment in this mixture, it will dry quickly. If you begin to paint with a brush, and the undercoat is still wet, it will dilute the drawing and cause it to blur. I suggest you allow it to dry to a tacky consistency before you begin to draw.

In the process of toning the surface the movement of the brush as it swirls and twists sometimes leaves suggestive shapes and designs that become quite exciting. Sometimes some of this can be amplified and left as part of the background of the finished painting. As has been mentioned several times I prefer to draw with the brush. If, however, you prefer using charcoal be sure to "fix" it with a spray fixative before painting so the charcoal dust does not mix with your paint and "dirty" the color. Also, if you work on a gesso coated board or other surface instead of canvas use the same procedure for the same reasons and the same results.

Gradation of Values

This figure was done to demonstrate some of the modeling process. The light is coming from a little left of the viewer. The gradation of values beginning at the head are rather deep; they gradually lighten as they come down the figure. They are most intense in the area of the buttocks, which also creates the deepest cast shadows. This range from dark to light to dark is shown in the panel alongside the figure. Notice how the subtle gradation of value is handled on the back of the figure in relation to the more contrasty areas where the light is strongest. The greatest difference between light and shadow is on the lower part of the figure.

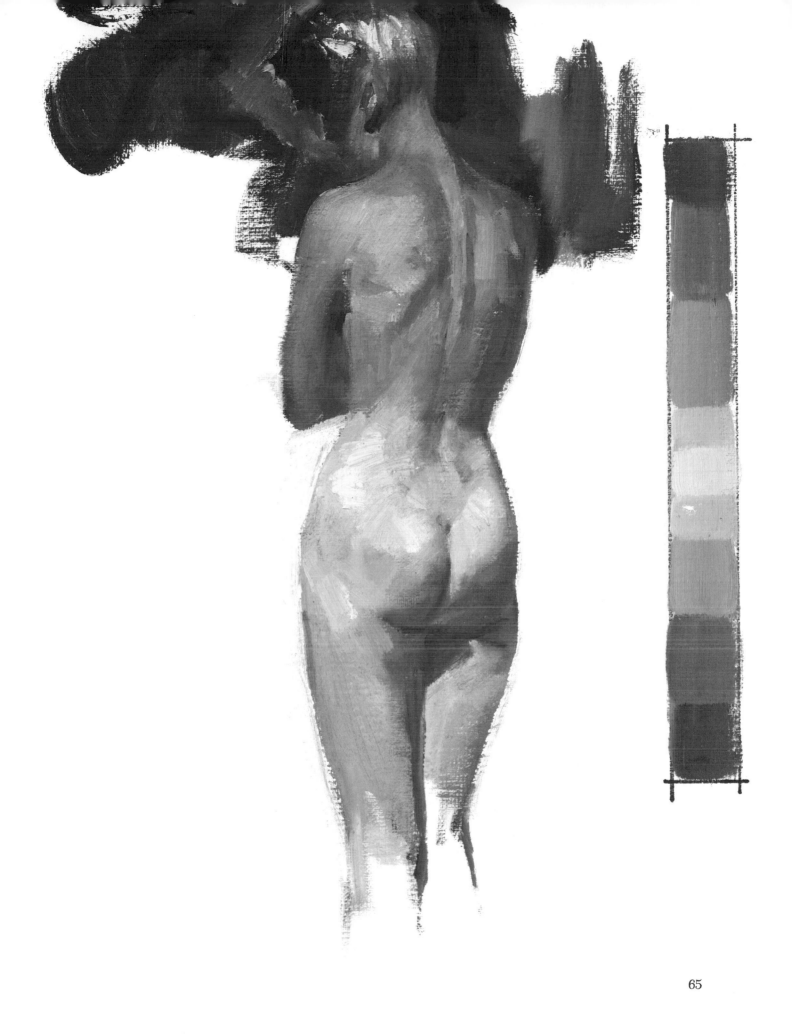

Edges

The diagram at the right with the gray value next to the black, is separated by what we call a hard or sharp edge. This is the type of edge that is used on the corner of a box. The light gray might be the side facing the light. The black would be the side away from the light. Between the two there is an absolute corner, so that the edge is hard without any blending.

This diagram has the same two values, the light gray and the black side by side, but by feathering or pushing the brush back and forth between the black and gray at the edge line, you will pull some gray paint into the black and black paint into the gray. Then to create the real soft edge, take your brush and pull it down in a vertical motion, and this will blend the gray and the black together so that we have a softening of that edge. This is the type of edge that would be seen on a column or object that is tubular in form.

This rough study demonstrates the use of hard and soft edges. The light-struck side of the figure has rather soft edges in the rounded forms. Two places have slightly harder edges. One is along the chest where the ribs come close to the surface and the other is the tip of the hip bone. Usually hard edges are only apparent in the figure when the bones come close to the surface. The principle areas other than the head, hands and feet are: the clavicles (collarbones), ribs, elbows, shoulders, wrists, hip, knees, fibula (shins) and the ankles. Very soft edges occur on the upper legs between the light and shadow areas showing the slow transition of the large rounded forms. Reflected light in the shadows enhances the curve of the form as well.

Reflected Light

The examples opposite demonstrate not only the edges, and the values as we've shown, but, also, the use of reflected light. Reflected light is light that bounces off a secondary surface and throws some light into the shadow area. In the cube we see a reflected light projected into the shadows. Reflected light usually enhances the illusion of roundness. The ball and the tubular objects demonstrate how to create soft edges as well as the use of reflected light in the shadows. Reflected lights are never as light as the area in the direct light. The darkest area of the box is along the edge that separates the light top plane from the shadow edge that is farthest from the light. This edge is affected least by reflected light. Optically it appears darker because of the strong contrast with the adjoining light surface. The use of this knowledge and careful consideration of reflected light helps in creating the illusion of form and solidity.

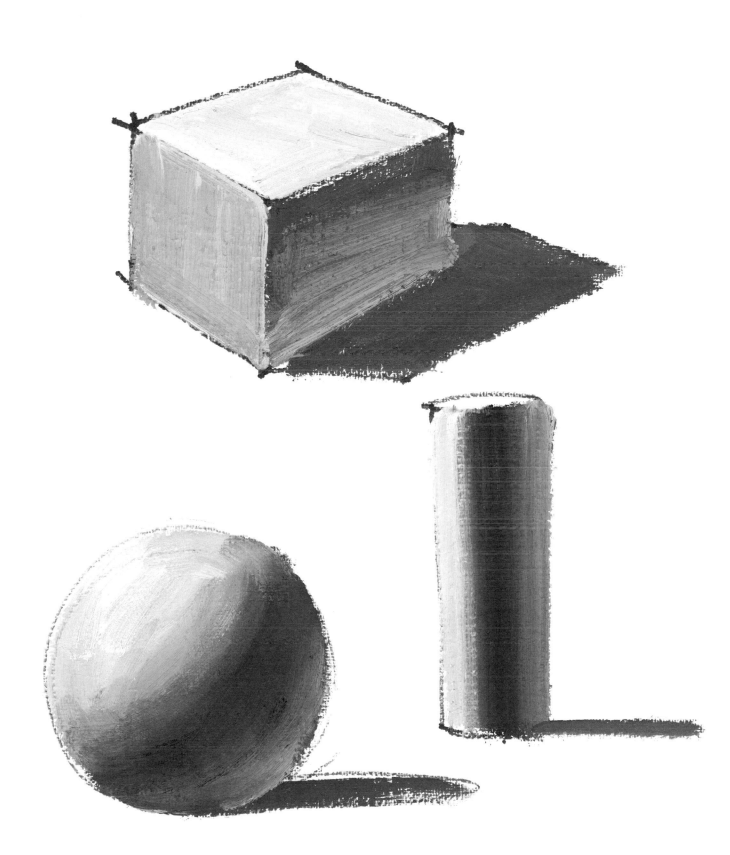

Accents

The figure on the opposite page was painted with a simple light source. The light is coming from the front, left of the figure. This gives an opportunity to show the various accents or highlights that are brought out by the underlying bone, helping to give the figure realism and believability. All of the circled areas are where the bone comes close to the surface. Here the skin is tightly pulled over the bone creating a hard reflective surface. Accents are generally the lightest values on the figure.

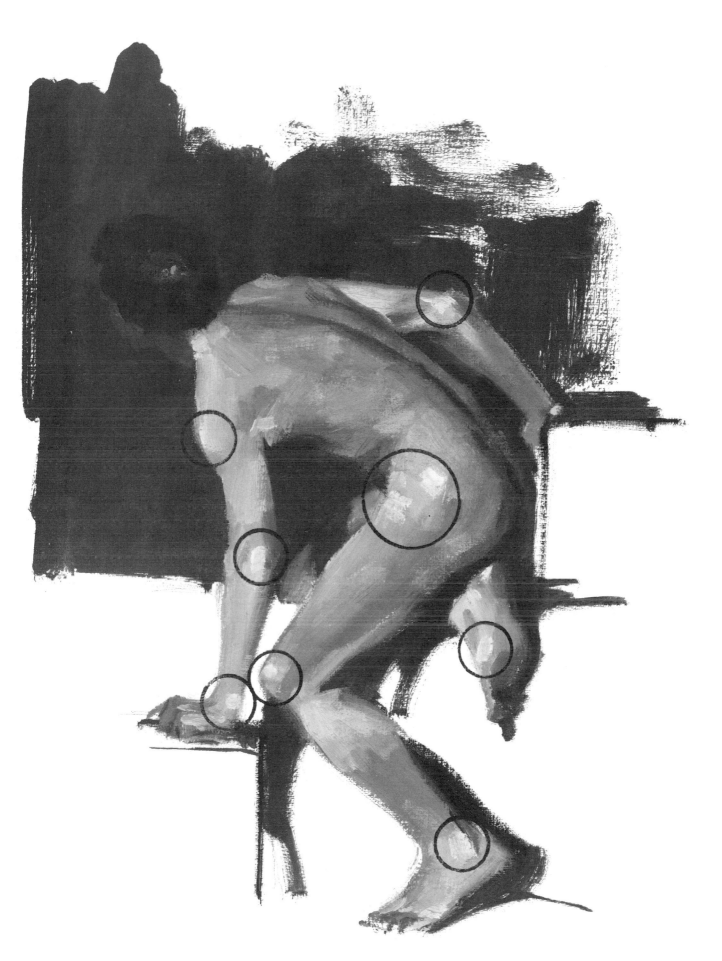

71

Planes

The figure on the opposite page is lighted from above. From our vantage point the light areas appear quite small. However, the light that shows clearly describes the form. These areas are called planes. The entire figure can be suggested by just these light-struck areas. The closer they are to the light source the lighter they are in value. As they recede from the light they deepen in value. The hardness or softness of the edge between the light planes and the shadow areas depends to a degree on how large the surface is that is hit by the light. On the chest, for instance, some of the light edges appear quite soft, while the light planes on the legs are smaller making for harder edges.

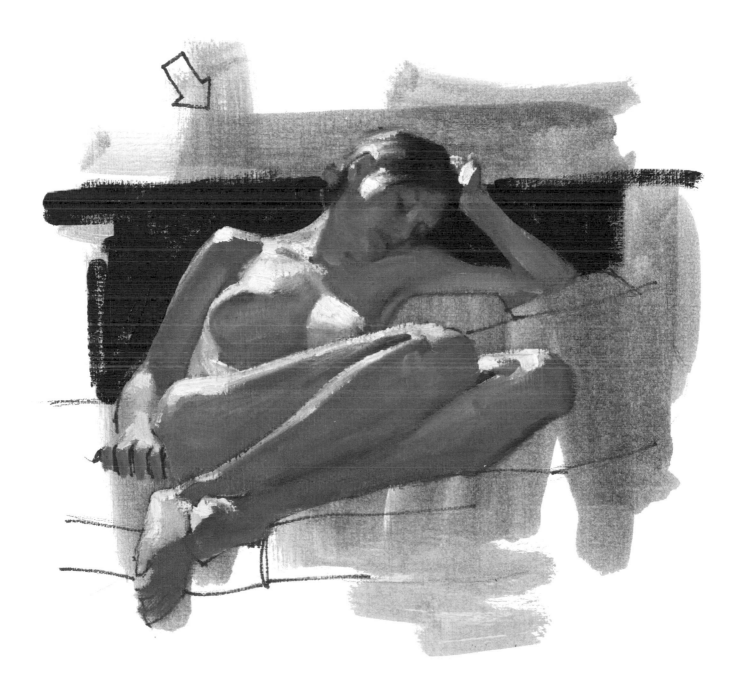

Smaller Planes

This figure has been included to illustrate the effect of small planes on top of larger planes in creating form. On this figure the light-struck side is actually one entire plane, the shadow side is another. Within the light area are many smaller surfaces that either face the light more directly or lean towards the shadow side. Each of these small surfaces must be suggested if you wish to create a convincing figure. To do this and retain the overall solidity of the figure requires careful value adjustments. Try to keep the range of values in the light area, lighter than any of the values on the shadow side. As you study the sketch, note the small planes, very light in value, that are on the cheekbone, breasts, shoulder and abdomen. They are not just highlights but definite flat surfaces. These surfaces can be painted quite broadly and will help to give a softer flesh-like texture to the body. Examine this carefully in the enlarged detail on the facing page.

Most of the basic problems of figure painting exist in any project regardless of pose or lighting. For this reason they bear repeating.

In this enlarged detail, the reflected light clearly demonstrates the form of the breast and arm within the shadow but does so without breaking up the shadow area. None of the values are as light as those in the light-struck areas of the figure. Note that the shadow on the model's right breast is relatively light compared to the left. This happens because of the reflected light from the left breast.

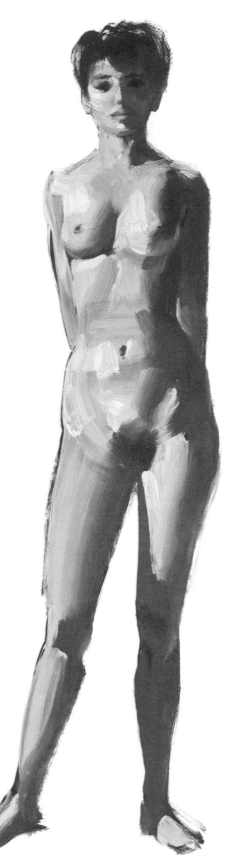

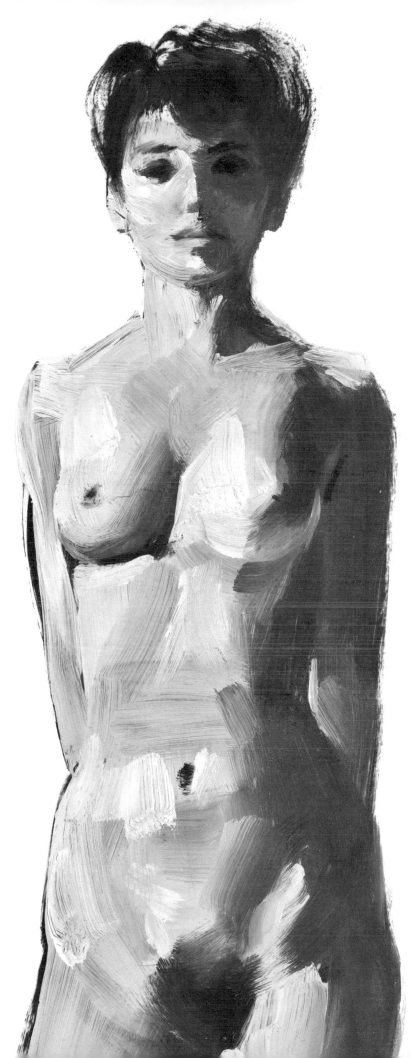

Texture with Paint

The malleability of oil offers the artist an infinite variety of surface textures. With experience comes a feel and understanding of the medium and how you can make it work for you. No doubt you have, or will in time, develop your own ways of working. You'll discover how to mix the paint to make a thick pile-on effect or run it as a thin glaze or wash. With practice you will be able to control subtle areas with a small sable brush and offset them like bold counter-points in music, with thick, broadly painted passages vigorously applied with a knife. It is this kind of variety that makes for interest in painting.

Often the brushwork, surface quality and paint texture of a painting is as individual as the artist's signature. Such uniqueness will only come after much work and searching. It is worth the effort. I urge you to experiment with a variety of brushes and painting knives. Strive for control but do it boldly. And remember, it's not *how* you arrive at the desired effect that counts — it's achieving it.

An old story has it that Goya was asked by an admirer *how* he painted a particular area in one of his pictures. Goya looked puzzled, said he didn't know but he added: If, at the time, I thought it should be painted with a broom I would do it with a broom!

Effects

In the painting on the facing page the canvas was first toned with a thin mixture of gray. After the drawing was completed with the basic forms, the shadows were painted in. The mixture of pigment for shadows was thin enough so it wouldn't pile up, but thicker than the toning mixture. All the dark areas were brushed in with this consistency of paint. After the half tones were developed the paint was made progressively thicker for the lighter tones. The heaviest impasto was used for the highlights. During this time heavy paint both dark and light was added to the background with a painting knife. This heavier paint lent body and substance to the background. The knife treatment serves as an interesting texture in contrast to the figure.

This exercise was, in a way, an exaggeration of what painting is all about. "Start thin and end thick" was the old axiom but, of course, that is over-simplification. A less restricting statement might be to "start at the beginning, do what is needed and end at the finish with fun in between."

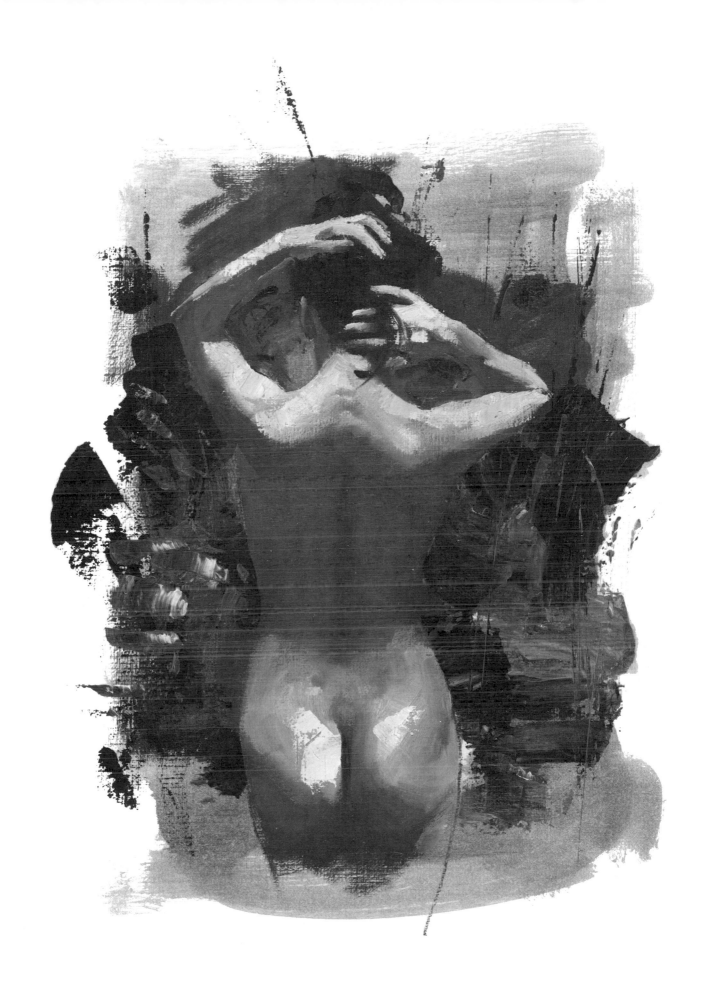

7 Color

Our choice and use of color is a highly personal and variable thing. Each of us responds to color in our own way. Until we start to paint and are forced to analyze what we see, we usually think of color in rather vague terms. We identify things as being wine, or rust color, or baby blue and oddly enough, most people seem to understand what we mean. To paint effectively with color you must be more exact. You don't, however, have to become too exact. You can keep it personal and non-scientific if you learn to recognize and understand a few simple facts about the properties of color.

To begin at the beginning — there is no color without light. Of course, white light — sunlight contains all of the colors we can see. The range of color in white light, as broken into its multiple wave lengths by a prism, is far greater than anyone can match on a palette. This is important to remember: an artist cannot duplicate the colors he sees. He can only approximate them and with thought and skill try to create an illusion of the colorful image that enters his eyes. The fact that white light contains all color is important to the physicist; it is not of much importance to the artist. Indeed, with paint, the opposite is true. If you mix all paint colors together the result will be a dirty, gray black.

Over the years a number of color systems have been formulated. All of these have merit and lead to logical conclusions. For me, however, they are all too exact and scientific and tend to be inhibiting if I think about them too much. Basically, I concern myself with four main principles of color: 1-hue, 2-value, 3-intensity and 4-my intuition. I believe you should have a working understanding of the first three and with practice and experience develop and rely on the fourth.

Hue means the name of the color itself — red is red, blue is blue, etc. The important quality of hue is the warm or cool sensation we feel when large amounts of it are used in a picture. The colors on the red and yellow segment of the color wheel are warm. The colors on the blue, green, violet side are cool. The problem is there are all kinds of warm-cool variations of each hue. It is the overall color relationship that counts most. Understanding that relationship depends on experience and your intuition.

The value of a color is its lightness or darkness. As in black and white painting, correct value is paramount. Some artists use the terms tints and shades of color — they are referring to the color's value and intensity. By adding white to a color you create a *tint*. If you add black you would be making a *shade*.

The power of a color is its intensity. How bright or how dull is it? It's easy to reduce the intensity of a color directly out of the tube; just add a touch of white or black or the color's complement. It is somewhat more difficult to change the intensity, however, if you do not wish to alter the value. It is also more of a problem to increase the intensity of a color.

With an understanding of the three dimensions of color you should be able to analyze what is right or wrong about what you have painted by intuition. What we look for in painting a picture is an overall harmonious relationship. When we see it and feel it is right, we don't have to worry about how we got it. When the picture looks wrong and

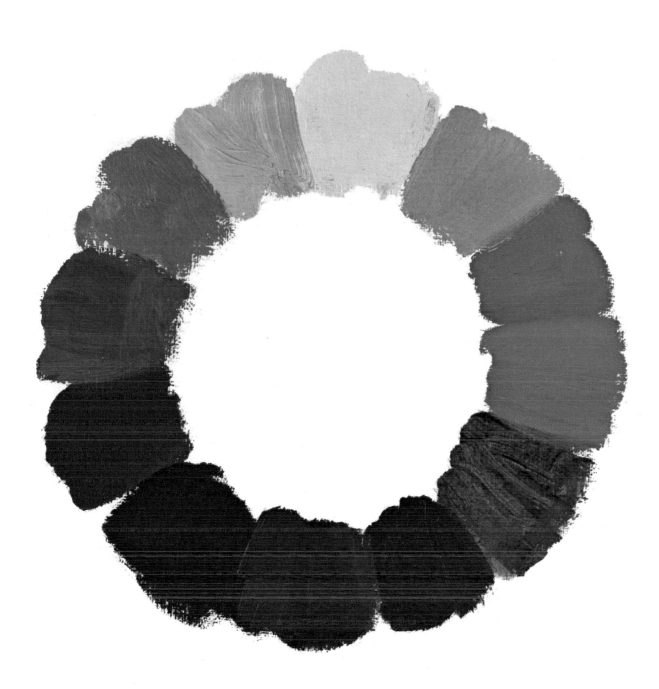

feels wrong, then we must go to work and figure how to adjust the hues, the values and the intensities to make it right. Nobody ever said it would be easy.

Mixing one color with its complement will reduce its intensity and gray the color. All of the colors on the color wheel are mixed from red, yellow and blue right out of the tube. As you can see, mixing the red and yellow together creates the secondary color, orange. If you use more yellow than red, you will have yellow-orange. If, on the other hand, you use more red than yellow, you will have the red-orange. This carries through in the other two primary colors as well. The color directly across the wheel from the primary is known as a complementary color. The complement of yellow is violet; the complement of red is green and the complement of blue is orange. If we mix adjacent primaries and secondaries, we have an added group of colors. These are intermediates.

Warm and Cool Colors

As mentioned, the terms warm and cool colors refer to hue rather than value or intensity. By dividing the color wheel in half with yellow and yellow-green at the top, and red-violet and violet at the bottom, the hues in the left half of the wheel with orange at the center appear warm while those on the right with blue in the center appear cool. Any hue can be warmed by adding yellow, and any hue can be cooled by adding blue. The use of warm and cool colors in figure painting is important. The local color of flesh, influence of light, the shadows and reflected light all require careful consideration.

As an artist you have to teach yourself to recognize a great range of color variation. You must learn to see *cool* reds and *warm* blues. Of course in relation to blue there is no cool red, but compared to other colors on the warm side of the color wheel there definitely are a multitude of *relatively* cool reds. The word to remember is *relative*. Everything in your picture must relate. This does not mean that your picture must be painted in all warm colors or all cool colors. Certainly, you can have a mixture of both in a picture so long as you don't lose the overall harmony.

Technically, black, white and neutral grays are not colors because they lack hue and intensity.

However, they can be warm or cool. Be particularly careful if you use black to modify a color. Ivory black and Mars black will tend to warm the mixture. Lamp black will cool it. (It's safer if you want to reduce the value and intensity of a color to use the color's complement.) There is also a difference in white paint. Flake white will give your mixture a warmer quality than will zinc white.

Here are examples of the warm and cool of the same hues. The colors in both rows are the same except the top group has been cooled with blue and the bottom warmed with yellow.

Aside from the aesthetic qualities involved in warm and cool colors, there is also a useful practical consideration. This grouping of color bars shows how cool colors tend to recede and the warmer colors come forward. Selecting colors carefully is an excellent way of increasing the illusion of depth and adding dimensions to a painting.

Here is an arbitrary use of warm and cool colors to enhance the feeling of roundness to a form. The warmer colors, light in this case, and thickly painted, are on the forward surface of the column. As the colors and values recede around toward the rear they become progressively cooler, and the paint application thinner.

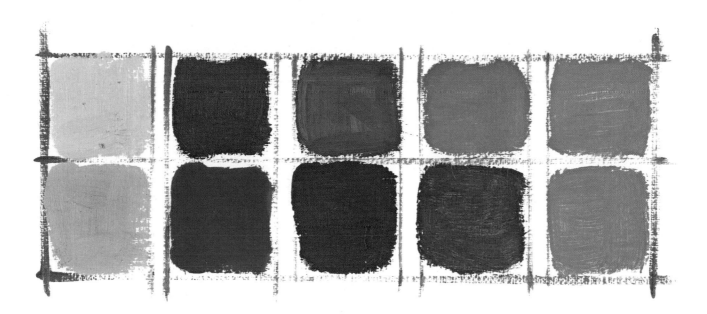

Creating Space Around The Figure

This figure is an example of some simple warm and cool considerations. The figure itself is relatively warm, particularly in the shadows. The light-struck areas are a bit cooler. The background is cool in the lower section and rather warmer at the top. The variety of value, color and paint handling in the background was to create a feeling of space around the figure and to serve as a contrast to the unity and form of the figure.

The basic flesh color was alizarin crimson and naples yellow mixed with white. Green and vermillion were mixed with this to gray and deepen it for shadows. Varying amounts of orange and yellow were added to the torso shadows to give them a warm luminosity. The deeper tones on the legs are similar to the basic shadow color. Note the hard and soft edge treatment on left hip and lower legs. The right shoulder and neck is blended into the background to make it recede.

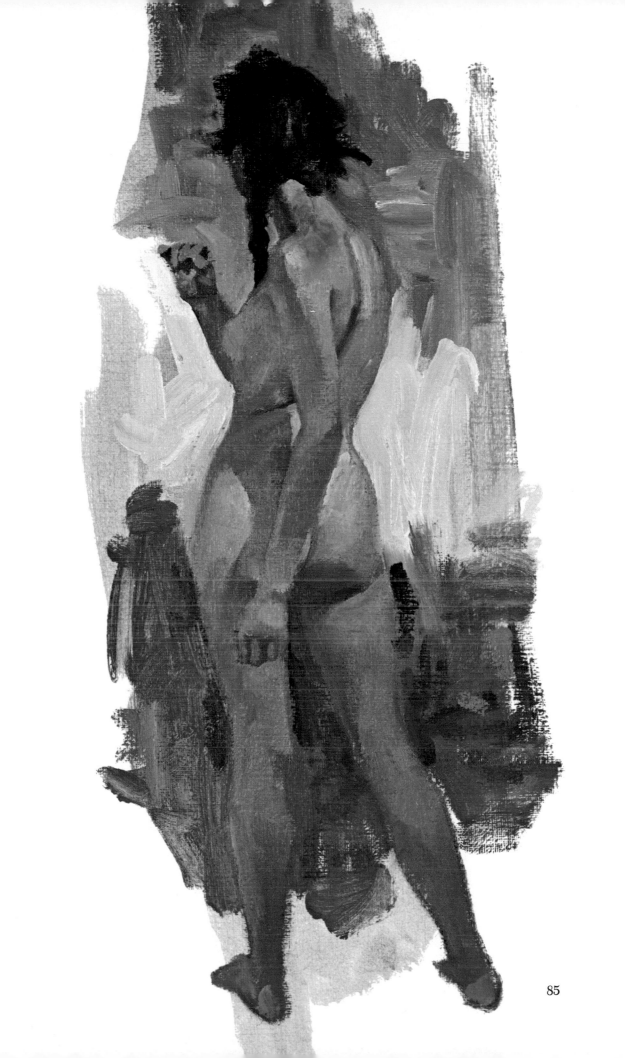

85

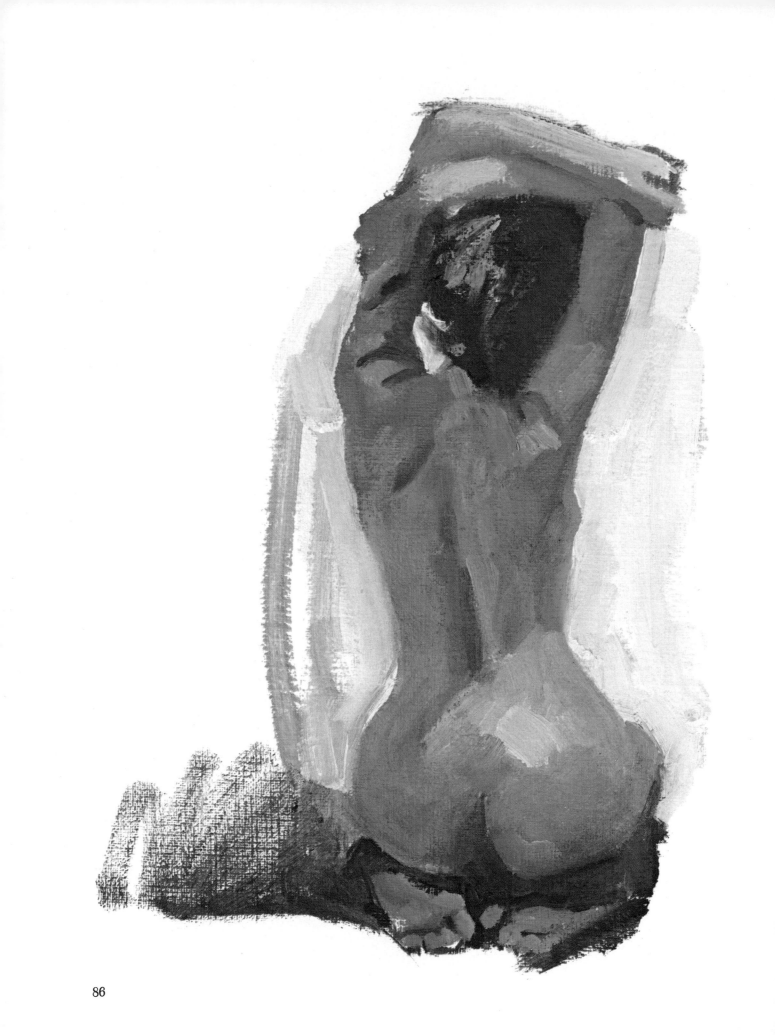

Grays

A mixture of cerulean blue, cadmium red light, and white give a fine cool gray as shown on the model's back.

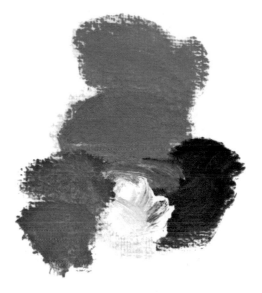

Cadmium yellow deep, alizarin crimson and cerulean blue create a warmer gray used on right buttock.

On left buttock a mixture of cadmium yellow medium and cerulean blue was used for cooler shadow area.

You will rarely find an opportunity to use the pure color right out of the tube. Most of the color you'll use will be grayed mixtures. This is particularly so when you paint flesh tones. The grays of flesh are, of course, not arrived at by mixing black and white. They are mixed from a variety of different colors as shown. Notice the number of subtle gray tones that are used on the back of the figure. The painting suggests only a fraction of the color evident in the model but, I feel the illusion of realism and luminosity was successful.

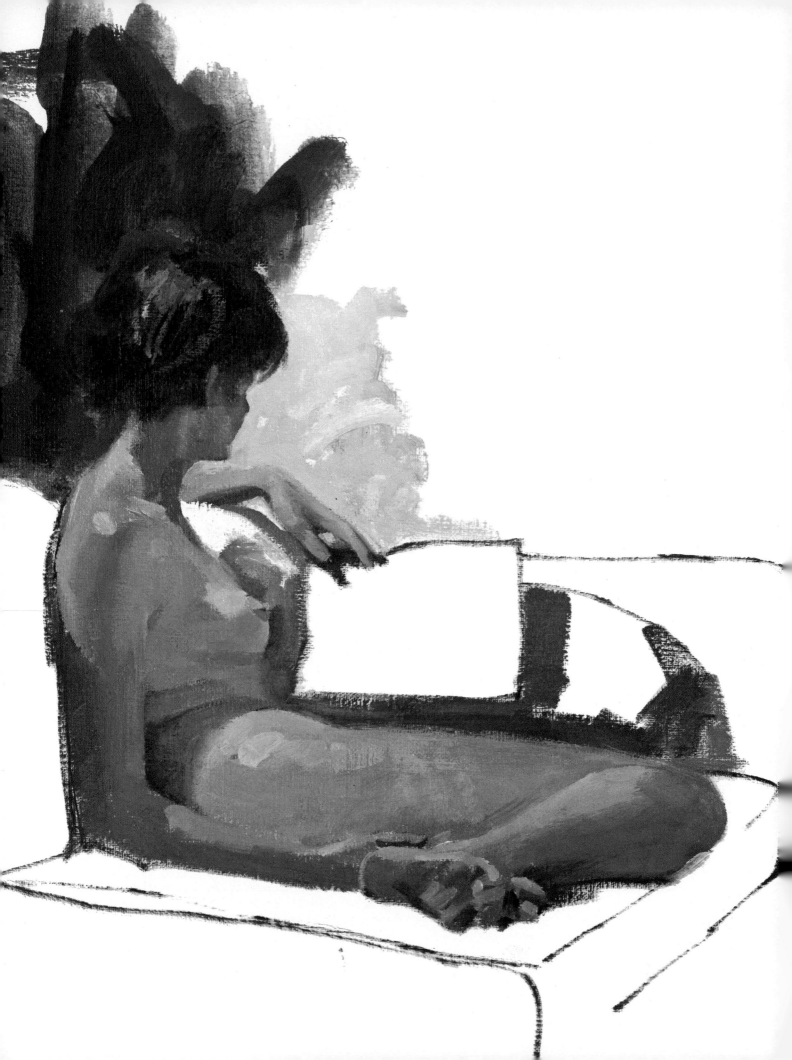

Warm and Cool Reflected Light

No doubt you have noticed that the paintings in
this book have been kept quite simple with little
emphasis on the background or details. There is so
much to learn about the figure it is best to elimi-
nate all except the most essential. At first glance
this pose may seem simple enough, but there are
many subtle variations involved. Note how the
shadow on the torso has cool tones within it and
the reflected light is projected up from the direct
light that strikes the hip and pelvic area. This cool
light in the shadow is opposite the warm light that
strikes the model on the shoulders and neck. Again
it is a problem of warm and cool color relation-
ships. In general, if the direct light source is warm,
the shadows will become cool. If the direct light is
cool, then by contrast we use the warmer colors in
the shadowed areas. Reflected lights usually seem
to be cool but you will sometimes encounter rather
warm reflected lights if the reflecting surface is a
warm color.

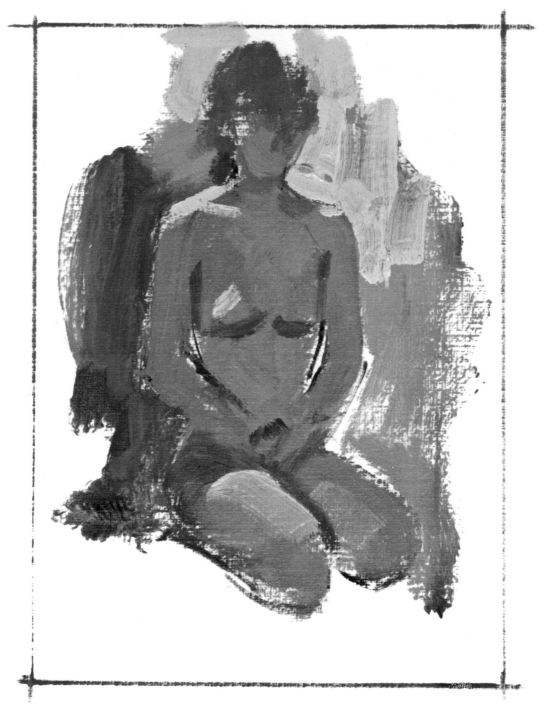

Color and Mood

Color is a key ingredient in establishing a visual mood. In this sketch I wanted to create a light, happy attitude. The bright cheery, predominately warm colors easily set the desired mood. You need not limit yourself in your final painting to these few colors, but you should not add many that will detract from the overall effect.

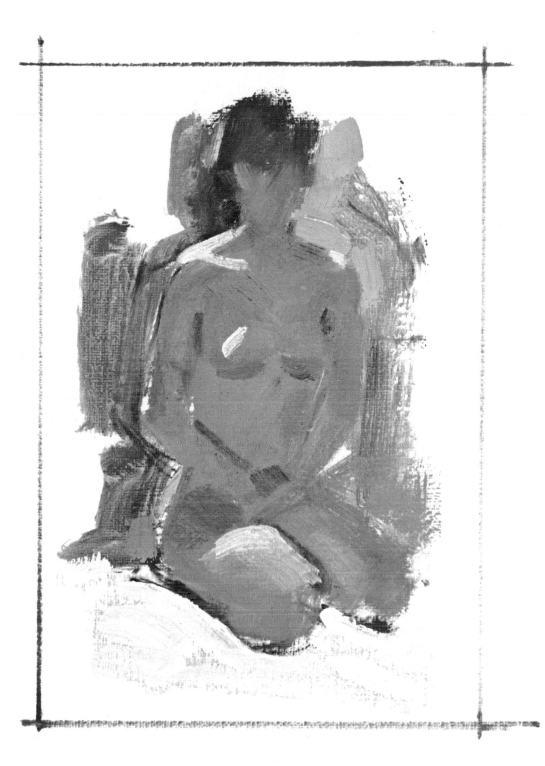

In this sketch the pose and direction of the lighting are the same, but the colors were changed to develop a somber or sad mood. Lower values and the cool color add to the general depressed mood.

When planning your color and values always keep in mind the mood you wish to convey with your picture. The psychological aspects of color are basic and universal.

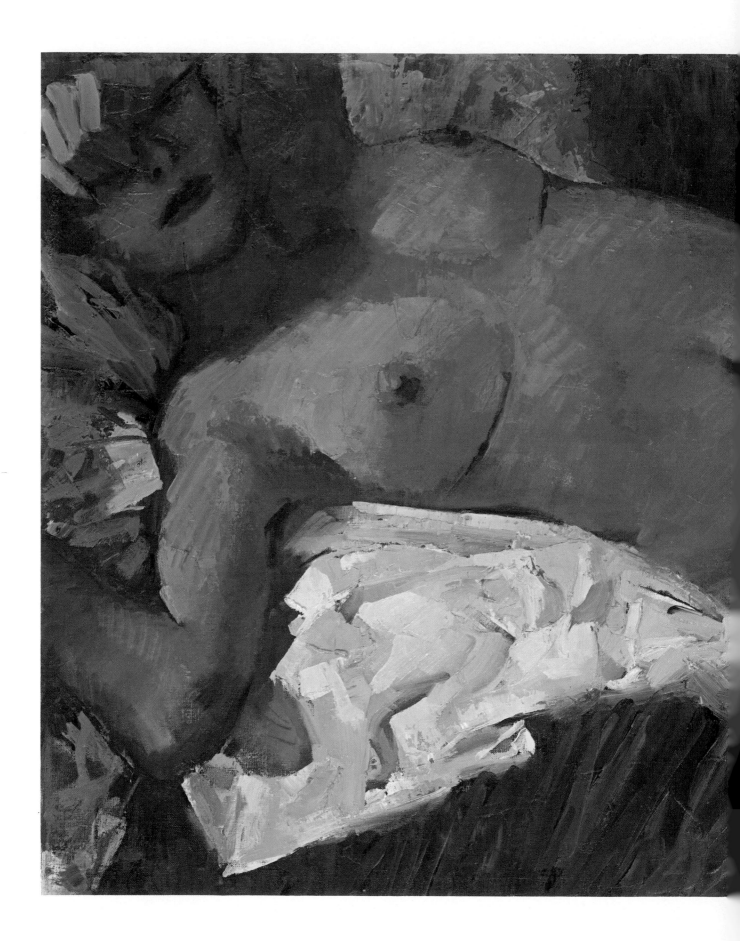

94

This painting was done mostly with a painting knife and shows the use of cool light source and the warm shadow areas. There is a variety of color in the background, and you'll notice that some of this color has been brought into the shadows. Because the painting is rather low key, the drapery in the foreground has been made quite light for contrast and compositional strength. A yellow drapery was selected as a nice complement to the large violet-gray shadow areas of the figure.

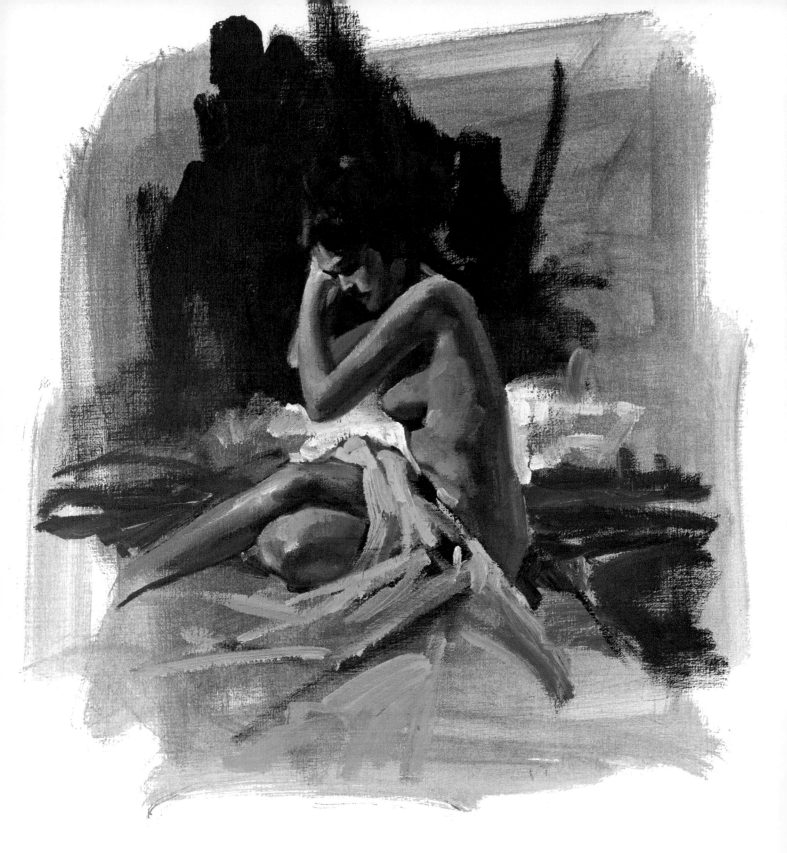

The painting was begun by toning the canvas with a grayed green mixture. Then the drawing was carried through with the basic forms, and the dark area behind the figure was introduced. The hair was purposely lost in the background to keep the attention focused downward. Next the shadows were painted on the figure, light areas were brought out and the red and white patches behind the figure were indicated. This is still a sketch but it shows how color-toned canvas helps establish color harmony. The use of complements (in this case red and green) also adds zest and interest.

8 Composition and Design

I have come to believe everyone, artist or not, is sensitive to the impact of design. Design is a basic human characteristic and its expression fills an important human need. Whatever we do, wherever we go we are confronted by aspects of design. Every man-made object is designed — unfortunately much of it badly. The greatest designer of all is nature. What is more beautifully contrived than a flower, a tree, the human figure?

Design and organization plays a vital role in our lives. Nowhere is it more vital than in building a picture. The artist cannot concern himself only with drawing and designing separate elements. He must draw and relate many elements to build a unified whole. Drawing and designing are one.

There are general rules, of course, for composing pictures. Such things as visual balance, variety of space and value distribution, scale, location of interest center, etc. can and should be learned. In doing so, however, keep in mind, design is not an exact science. You can't learn a set of inflexible rules and expect to have them solve all your compositional problems.

Composing a picture is a process of personal selection and rejection. You choose the elements (shapes, forms, colors, values) that are needed to fulfill your picture concept; you eliminate those that are not essential to it. Your own natural feeling for design, your intuition of what looks right will serve as your best guide through the rocks and shoals of composition.

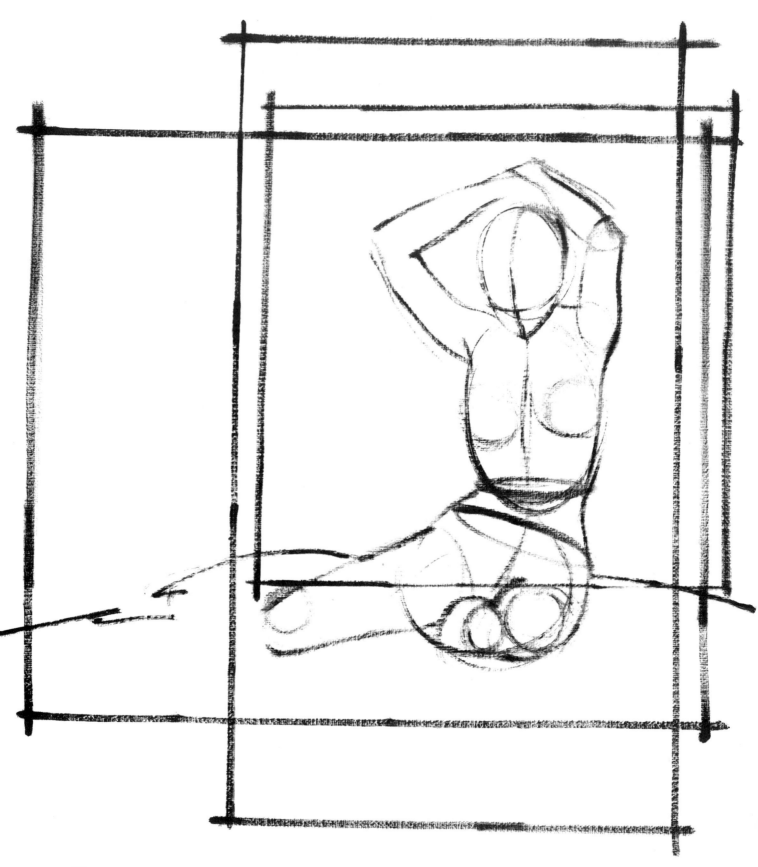

98

Picture Area

The first decision you must make in starting a figure painting is the shape of your picture area. In most cases the pose you select will dictate the answer. You should give it some thought, however, because the background elements and the mood you hope to establish may alter the area you allot to the figure. If you wish to paint a standing pose you would likely select a vertical rectangle as the picture area. If, however, you wish to describe the environment of the scene or suggest a mood of, say, loneliness a horizontal area might be more effective. I find it helpful at times, to make a very simple, rough compositional sketch suggesting just enough elements to assure me I'll be content with the picture shape I select.

In placing the figure in the picture area think hard about the space the figure will fill, how the forms will relate to the over-all area and the borders. And, above all, give thought to the shapes and spaces that are left over. Those negative areas are as much a part of the picture design as the positive shapes.

Your choice of size and placement of the figure in your picture area should be considered carefully. Ask yourself if you want the figure to dominate the space or be dominated by it. This is a key question that you must answer at the outset.

Obviously, you should work for a pleasing visual balance in your painting. I avoid a center or even balance because it is usually dull and uninteresting. Some artists, however, are able to make it work effectively. One I know has a rule about composition — decide what is important and put it in the middle. Such an approach might take the anguish out of composition but it is not recommended, at least until you feel you are a master of all phases of picture making.

As a general rule it is wise to fit the figure in the picture so that it does not appear to rest on or be supported by the borders. Also, try not to crop

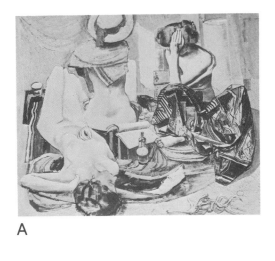

A

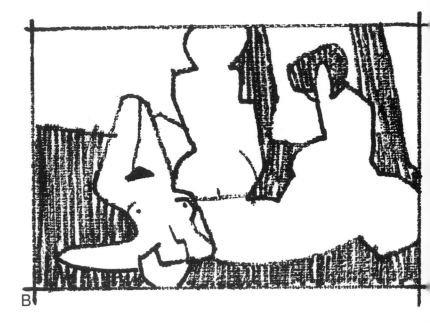

B

the figure at major joints — this is likely to create an unhappy, dismembered sensation. Although I may violate the precept on occasion, I usually try to avoid cropping a figure with the picture borders on more than one side. If, for example, the left arm is cropped I would explore ways of keeping the right totally within the picture.

Diagram A shows how Robert Fawcett grouped three figures (B). Two overlap each other and the third is held to the group with the foreground arrangement. The unity of value used in the background helps to isolate the figures as a single compositional unit.

The Degas painting (C) is an example of how rules can be broken with pleasing results. As shown in diagram D, the three figures are almost equi-distant from each other. The head of the standing figure to the left touches the top of the canvas; and her feet touch the bottom. The figure in the center is just that, right in the center, while the figure to the right is about equi-distant from the bottom border as from the top border. The compelling thing about this composition is that each one of the figures is in a different pose facing opposite directions. The attitudes and action of the figures are all the same; they are seen from a different concept. This is a lovely composition done by a master. In lesser hands it is not likely to be successful.

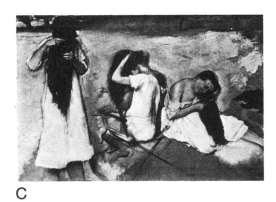

C

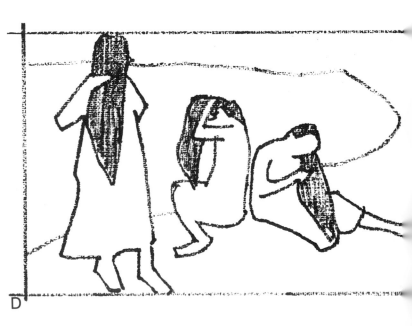

D

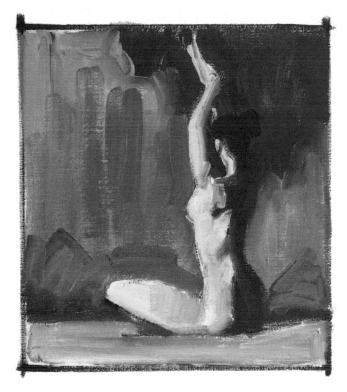

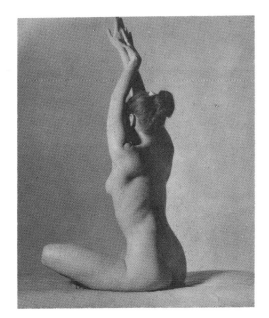

Value Pattern

We have already discussed the importance of values in rendering the figure, now let's consider what role values play in the success of a composition. The value key of a picture has much to do with the kind of mood the painting projects. A low key composition immediately gives us thoughts of mystery, gloom and fear. Such a mood can be given added intensity if enforced with other compositional considerations such as appropriate color and jagged or oblique lines. A high key picture is likely to express opposite emotions. When reinforced by color and supporting shapes a high key picture can create a happy, cheerful image.

No matter what key you choose to paint in, the important thing is to learn to group your values into a pleasing design. When you fail to arrange your values in a broad, simple design the result is likely to be confusing. Always try to create a definite value pattern along the lines shown in the examples on the opposite page. Study them carefully. Within these bold value shapes there are, of course, many subtle values variations but the units are held together sufficiently for the design to "read."

I developed this sketch using the photo as reference. The dark shape was added to break up the monotonous background. Notice the unity created in the simple value pattern.

This sketch shows how the figure and drapery have been used to create a series of shapes. The diagonal drapery shape separates the background and leads the eye to the figure. The plan was to establish a variety of shapes with a simple pattern.

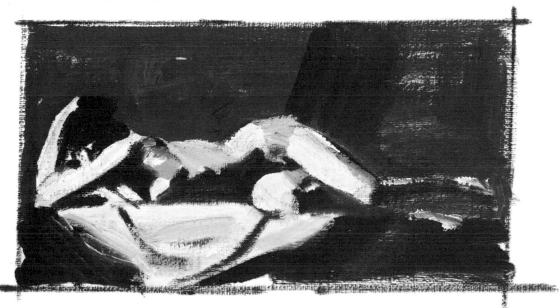

9 Head, Hands and Feet

The head is a special problem for the artist because the face is the mirror of our thoughts and emotions. In drawing the head we are immediately involved in more than controlling correct construction and proportions. We are confronted with personality, mood and attitudes that are looked for and recognized by every viewer. Each of us, from infancy on, have been looking at, studying and reacting to faces and facial expression. We have no doubts about what a down-turned corner of the mouth means; the effect of an uplifted brow or the glint in the eye of an otherwise poker face. In drawing and painting the figure we had better know how to control the head and face for, even if it is relatively unimportant in the picture, the face will surely have a bearing on the acceptance of our total efforts.

Probably the most important step in any drawing is good and careful observation. This is particularly true with the head and features. We are so used to seeing heads and faces we may allow preconceived knowledge to guide our hand rather than accurate observation. This can lead to trouble. For instance, with some variation we consider the features as symmetrical. Looking straight on this is generally correct. But, with just a slight tip or turn of the head the position of the features is considerably altered. The accuracy of your drawing then will depend on the accuracy of your observation not on an intellectual solution.

The form of the head is that of an egg with the small end at the chin. The back of the head, opposite the chin, is usually somewhat more bulbous than an egg. The important guidelines for placing the features are diagrammed on the following pages. It is better to study and practice drawing them than it is to read about how to do it.

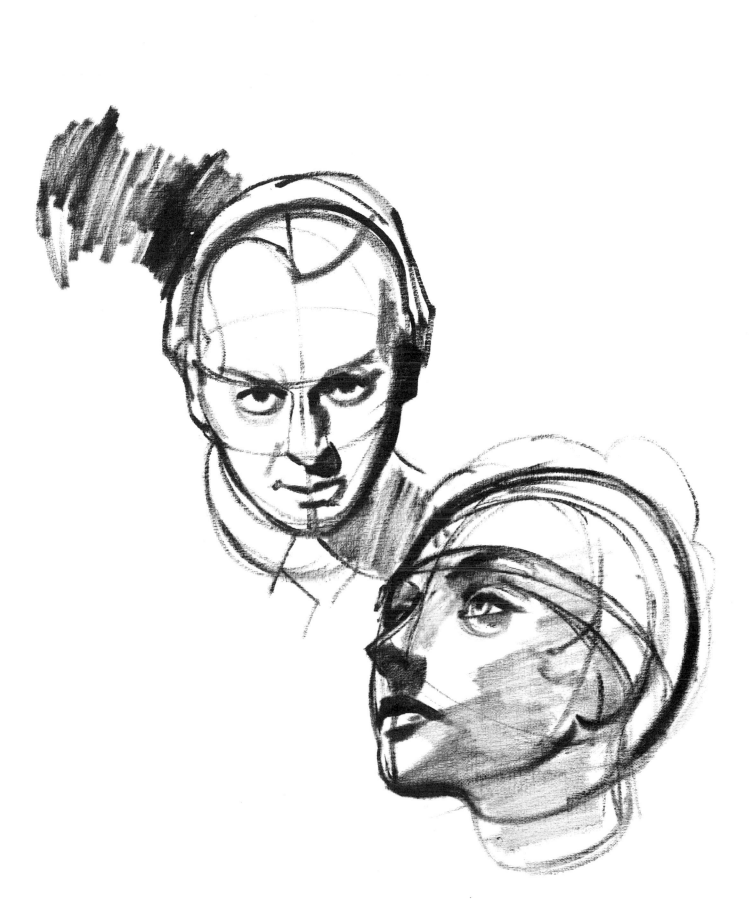

Guidelines

When "blocking in" the features on the egg head from a straight on front view, indicate the center line down the middle first. Then, half-way between the top and bottom of the head, draw a light line to show the placement of the center of the eyes. Just above the eye line judge the position of the brows and draw a line parallel to the eye line. Half way between the line of the brows and the chin is the bottom of the nose, and half way between the chin and nose, indicate the mouth. The ears can be considered to be the same length as the distance between the brows and the bottom of the nose.

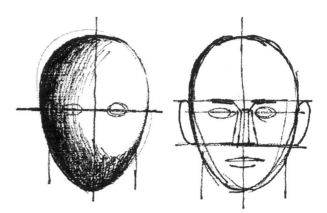

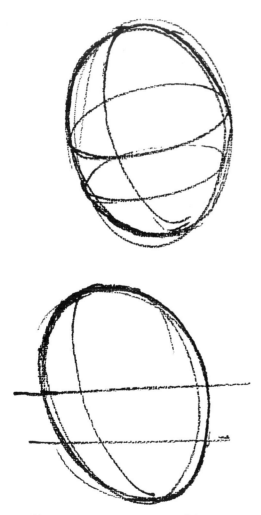

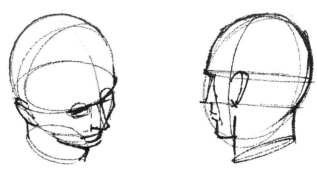

Be alert to the fact that features take on different contours as the head tilts and turns. Also, the proportions of the features change as soon as the head moves from a straight on angle.

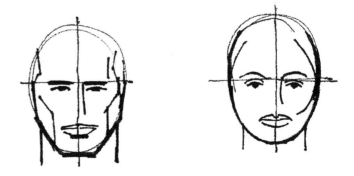

Always construct your guidelines in a circular way following the shape of the basic head form. Imagine you are actually drawing the lines on a real egg. Avoid running them in straight lines through the form. This will mislead you.

The difference between male and female heads is quite marked. There is a block-like squareness to the contours of the idealized male head. The cheek and jaw bones are more prominent; the eyes are proportionately smaller; the brows are straighter and the chin tends to be more square. In the female head the features take on a more rounded appearance with arched brows; proportionately larger eyes and the fuller lips. The chin is rounder and the face is ideally more oval in shape.

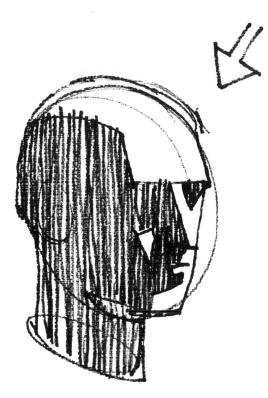
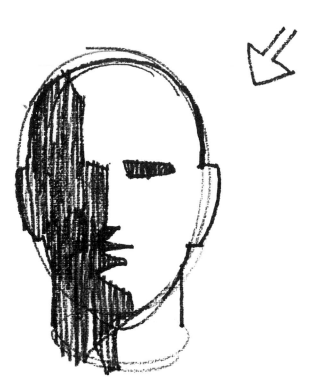

Features

The features don't just stick on the egg shape of the head. The eyes as you know fit inside the skull in definite, protective sockets. The egg form must be sculptured out to accept the eyes in their correct position. Also, particularly in a lean person, the temple area on either side of the forehead tends to flatten and the checks will be a bit hollow beneath the high point of the cheek bone. The lips and point of the chin may protrude a bit. All of these feature modifications to the egg shape can best be seen under a strong light that casts definite shadow patterns. Study these diagrams and *think* about the head and how the features fit on and in it.

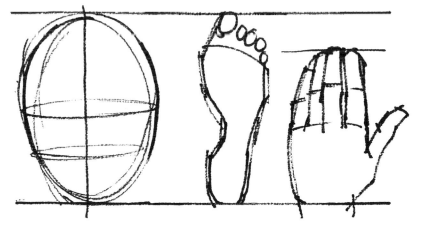

Here is a measurement guide you may find useful: Generally, the length of the foot is about the same as the length of the head. The diagram above also shows the proportion of the hand in relation to the foot and head. It's not absolute, but it is a good norm.

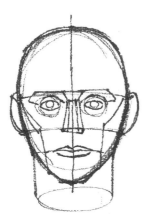
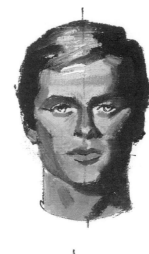
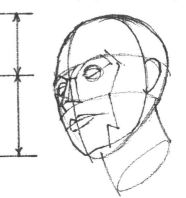
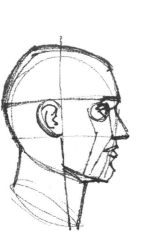

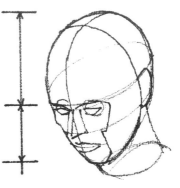

In drawing the head it is a good idea to indicate the guidelines first as we have stressed. This way you insure the features will be placed as correctly as possible. Then, when you start painting the head, you'll have a good basis on which to build. This doesn't mean you fill in your drawing like a number painting. You have to continue to draw and construct as you paint. The more you do it, the more you think about it the more sure you will be of the drawing.

Be aware that the thickness of the hair is added to the top of the skull. If you are not careful you may slight the skull area and reduce the head size, making it too small for the face. Plan the lighting and establish the planes in the shadows and light areas.

When the head is lifted up and viewed from below, the distance between the brows and the chin will be greater than the distance between the brows and the top of the head. Conversely, when the chin lowers, the distance from the brows to the top of the head lengthens, and the distance between the brows and the chin is less.

Keep It Simple

Try to see and analyze the figure or head confronting you in a simple, uncomplicated manner. Accent those parts that give strength and expression without concerning yourself with minor details. There is no need, at this stage, to indicate small, subtle value areas. Edit and modify to suit your artistic taste. Avoid doing a photographic reproduction or rendering. Make it a painting! You can say more than a camera!

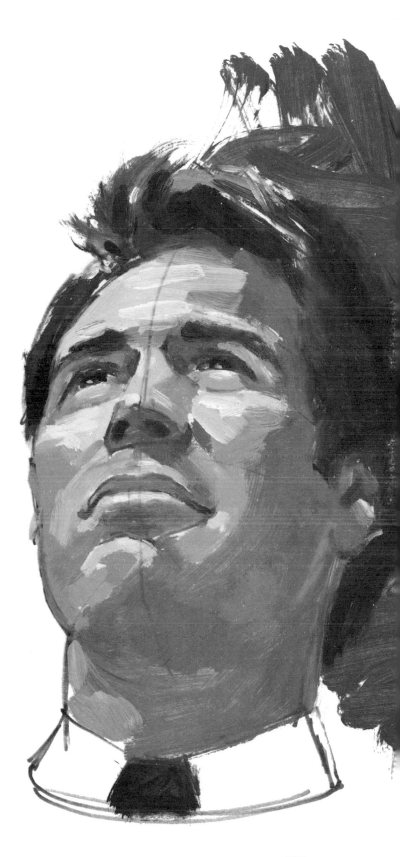

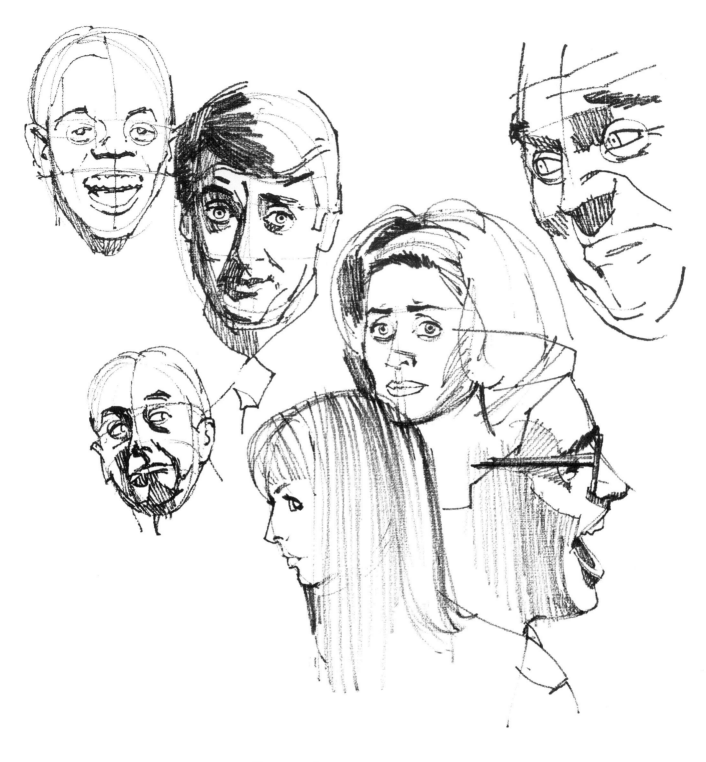

Expression

Use your sketch pad often to capture the various expressions that you see every day. It is fascinating to see, study and learn the subtle mobility of the human face. Draw with as few lines, tones, etc. as possible. It is truly said: What you leave out is usually more important than what you put in.

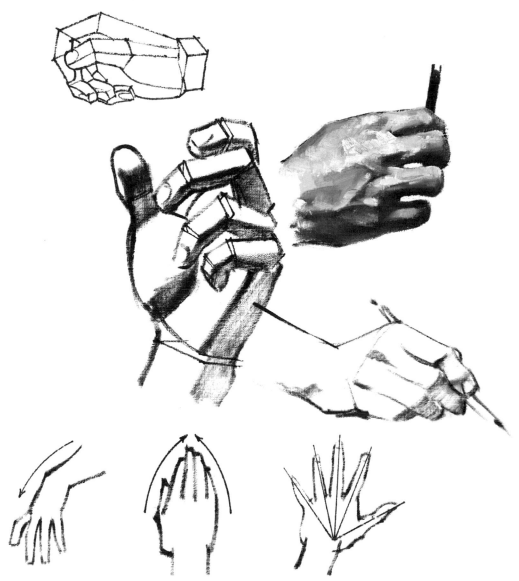

Blocking in The Hand

The hand is a marvelous implement capable of much expression and its utilitarianism is without peer. As we have demonstrated, the figure itself can be separated into various different elements. This, too, is true with the hands. The simplified version of the hand is easier to understand when each segment is considered separately with its own individual shape and form.

In drawing the hand it is a good idea to start with the gesture of the action just as we discussed in starting the figure. Once the general pose or action is determined then use the simple forms of the various sections of the hand. The palm has a kind of flat box shape with a rounded pad for the base of the thumb. The fingers can best be considered as being made from tapering cubes. Each finger

would have three sections allowing for bending and manipulation at each joint and knuckle. The thumb cubes require some modification, but can be easily broken down as shown. Using the simplified hand forms will help a great deal in controlling foreshortening as well as establishing the form and action.

Remember that the wrist is flexible and bends. This bending of the wrist gives that added movement and grace to the figure.

Hands taper up to the middle finger when the fingers are held together as above. This is important in capturing the character of the hand.

The fingers when they are outstretched radiate up from a point like the spokes of a wheel, the hub being in the palm of the hand, as shown here.

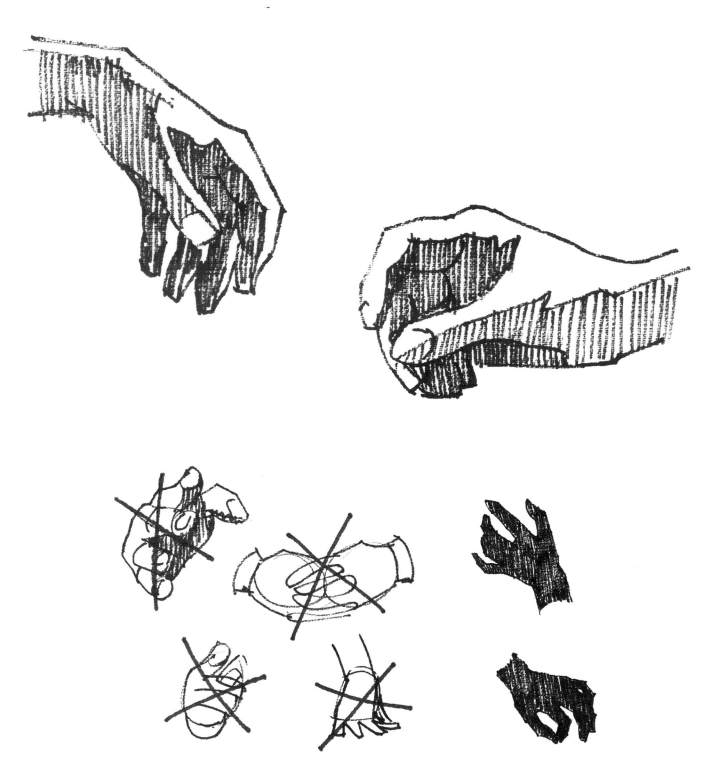

When posing the hand, try to place it in such a way the contours are easily understood and simple in shape. Let the light fall on it so definite planes are created. The shadow areas should be kept large and simple to contrast with the light struck side. A clear difference between the light and shade on the relatively small form of the hand makes its expression more easily recognizable and believable. Until

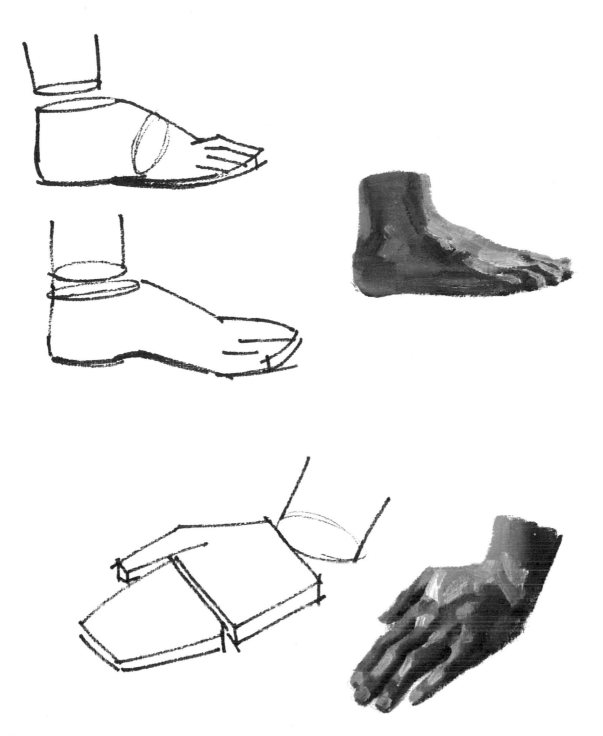

you feel easy constructing and drawing the hand, avoid poses that are too complex. Hands can sometimes be confusing and frustrating. It'll help to plan and think in terms of a hand silhouette as we did earlier with the complete figure.

The foot is a unique form that often looks wrong in a drawing or painting. In many ways the foot is more difficult to draw and make "look right" than hands. Hands can do so many things and we are so used to studying them we bring more knowledge to the job of drawing them. It helps to simplify the forms of the foot as shown but

the only real answer is careful observation.

The difference in contour between the inside and outside of the foot is quite apparent in the basic form diagrams. The inner arch of the foot curves up toward the instep whereas the outside sole of the foot is relatively straight, the toes causing a difference in outline.

Here is a two-stage demonstration of a simple hand pose. Try to keep in mind the simple, basic form of the entire hand, working in details and real fingers as you progress, but don't lose the original, simple contours and form.

10 Demonstrations

We are now ready to put together all the points we have covered so far as separate entities. And, for added dimension, we'll do it in color. For openers let's review briefly the major steps we have considered so far that are necessary to the development of a figure painting.

Probably our first concrete decision has to do with the figure's pose, but that decision must be reached in concert with our plans for picture area and the general mood we hope to project. It is hard to tell which comes first — it's the chicken or egg situation. Since we must start somewhere let's begin with the pose.

To help us establish the rhythm and action of the pose it is well to experiment with numerous gesture sketches. Once we find a satisfactory action, we'll go to work on building the figure with the basic forms. Each section is carefully observed and considered in terms of construction, proportion and foreshortening. While concentrating on individual parts we try never to lose sight of the overall action of the entire figure and how it relates to the complete composition.

Almost simultaneously with solving the drawing problems, plans for lighting, value pattern, color and design must be formed. Indeed, all of these considerations may take precedence over the development of the figure. It makes little difference in what order you proceed so long as you cover all the points and the end result offers satisfaction.

112

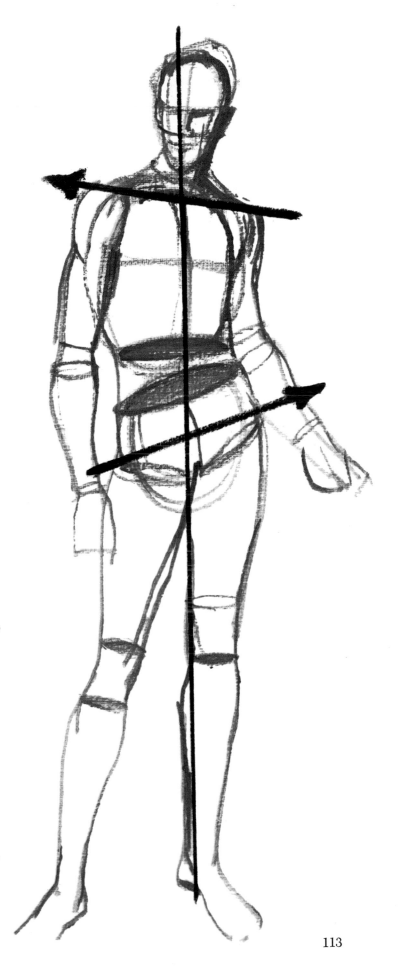

At this stage don't worry about technique. It is a well-known fact that the more you paint and draw, the more adept you will become. There is no substitute for practice. Trial and error is the great teacher. Direction and instruction are helpful, but in a way they are just counter-punching. You must take the initial steps yourself. No one can hold your hand while you paint.

In drawing the figure with the brush, I prefer to use a mixture of alizarin crimson and yellow ochre thinned with turpentine. The reddish color keeps me thinking in terms of the pinks and warm tones in flesh as an undertone. Also, if the under-drawing appears through or mixes with the flesh tones, the flesh will remain bright and clean.

Note the opposite slant of shoulders and hips in this pose. This is a typical condition when the weight of the figure is on one leg. This kind of subtle observation can be stressed in drawing the figure and it'll bring believability to the pose.

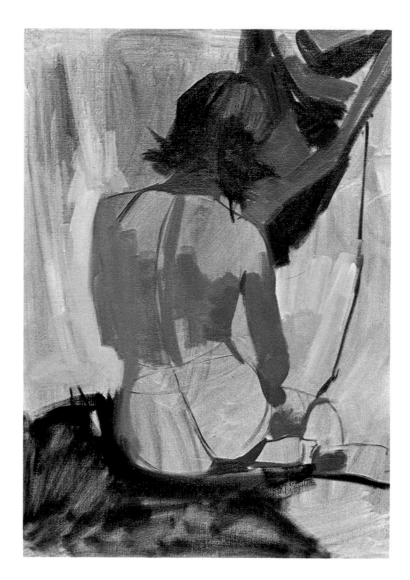

Step 1.

As mentioned earlier, I like to use the plastic coated canvaskin for sketches. However, for this multiple step demonstration I used a 20 x 24 inch canvas panel on which the pigment would remain wet and workable for a longer period.

For the toning mixture, a combination of burnt sienna and viridian with turpentine was used. I allowed the green to dominate the mixture slightly. After toning, the surface was left to dry until tacky. Some of this original half-tone is evident in the background.

Having already planned the composition, mood and pose, I proceeded to block in the figure carefully. This involved consideration of all the areas around the figure. I was mindful of the shapes and distance between the figure and the surroundings.

With the figure in position, I began to draw with the brush, using a slightly thicker mixture of alizarin crimson and yellow ochre with just a bit of burnt umber.

Shadows were indicated while drawing. I kept the floor areas dark to allow for overpainting. Other patches of color were suggested throughout the canvas to keep the entire painting going at once rather than trying to finish any one part.

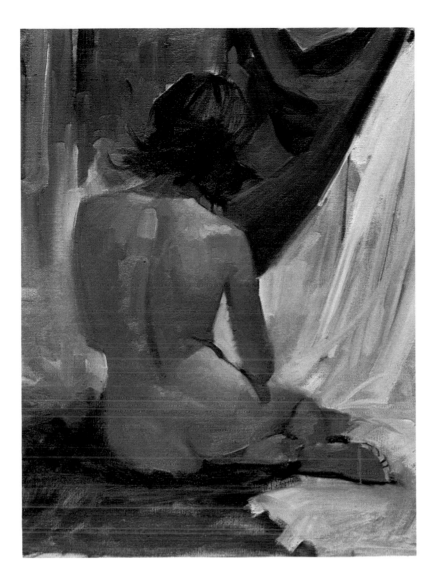

Step 2.

At this point I began to introduce a few of the flesh tones in light so I could gauge the values between light and dark more accurately. The flesh color was basically yellow ochre, cadmium vermillion, alizarin crimson, naples yellow and white in varying amounts, but always including a small bit of viridian. The viridian is to help maintain a harmonious color relationship throughout.

As flesh tones were put in, attention was given to the edges of the form where they meet the background. Softer edges were used to describe the large rounded forms with accents of harder edges to give substance, structure and add interest.

The drapery on the floor was started at this point. The over-painting was with light bluish tints to strengthen the foreground.

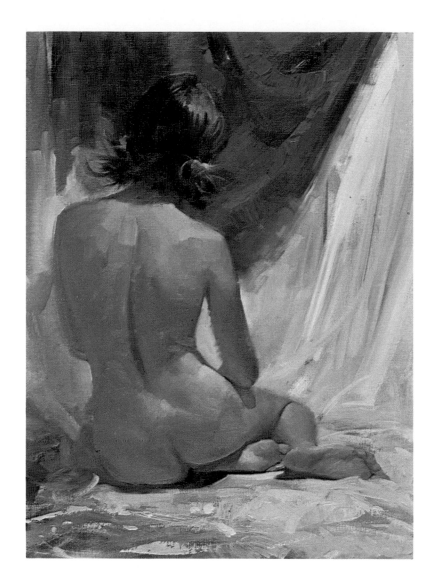

Step 3.

I used the red drapery because it would harmonize and complement the green tones. The background was kept simple with just enough definition to explain itself and add variety in shape, color, value and texture. Reflected lights were suggested in the shadows on the back and buttocks of the figure. Also, at this time, the highlights were added in the hair. The hair mass was allowed to combine with the background to take the emphasis off the head and to create a unity between the figure and the background. The feet were carried to completion, giving attention to the combination of hard and soft edges. This is quite apparent in the enlarged detail on the next page.

Detail

This enlargement shows the use of hard and soft edges. Notice how the soft edge and lighter value on the inside of the arm contrasts with the darker accents of the hipline shadow. This helps to show the fullness of the form. The very soft edge on the thigh and knee makes the area recede and appear definitely behind the lighter values and sharper edges of the foot. These contrasts heighten the realism and depth, while at the same time add variety and interest to the painting.

Flesh Color

As you know, flesh color is seldom one pure color that comes right out of a tube. It is a mixture of colors. We can begin with a simple mixture of alizarin crimson and naples yellow. This with white gives us a pleasing basic flesh color. Adding a touch of viridian grays it nicely. It can be given another character with the addition of violet, cadmium vermillion or burnt sienna. Of course, flesh color is relative, for it is influenced by other color close to it. Also, adjustments must be made for shadows and reflected lights must be considered. Flesh can appear to be a cool or warm color. Obviously the lighting will influence it as well. All of these things should be taken into consideration as you analyze your model or reference material. There is no substitiute for careful observation.

Large Planes

For this sketch the light on the model was from above. The in and out thrusts of the forms of the body, even in this rather static pose, are readily apparent as shown in the black and white diagram. Study your model carefully before you begin to paint. Squint your eyes as you look to determine where the planes are and how they can help create the feeling of form in space. The feeling of depth and solidity can be effectively achieved this way.

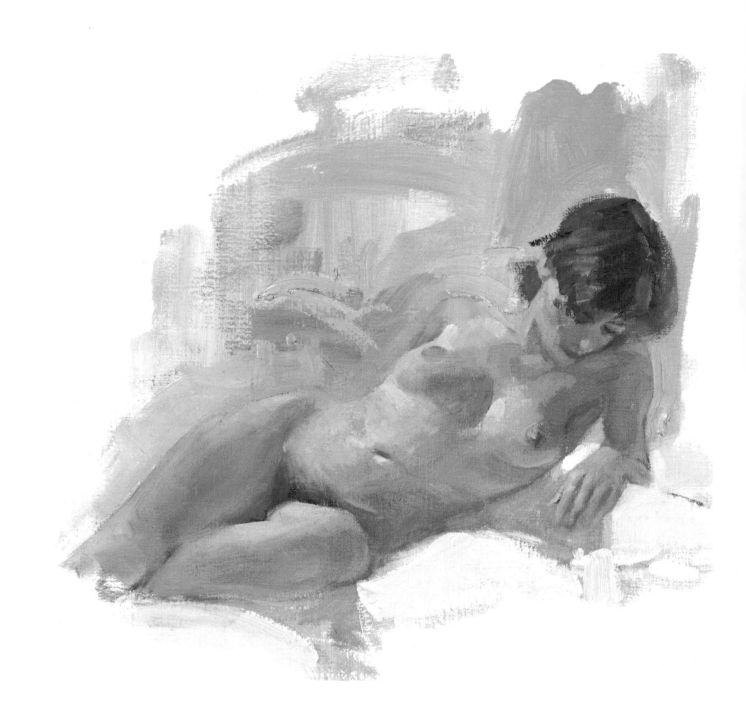

High Key

Value contrast in high key painting must be subtle and quite restricted in range. At least, the predominant look of the picture should suggest close, light value relationships. Small darker accents here and there can be used and they will prevent the painting from looking washed out. It is a good idea to place a small patch of deep valued color somewhere near the picture area to serve as a reminder to keep the values light.

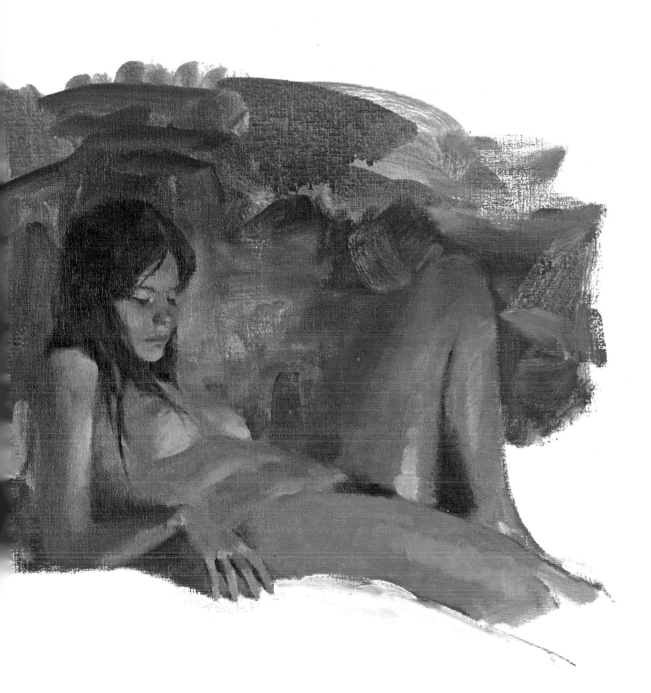

Low Key

When painting in a low key the dominate look of the picture should be in the low range. The values should have a relatively close relationship to each other. Whatever highlights or light areas that exist should be held to a half-tone or darker so that when you squint your eyes, the forms and shapes blend together. Some of the forms are lost in shadows and the color has less brilliance.

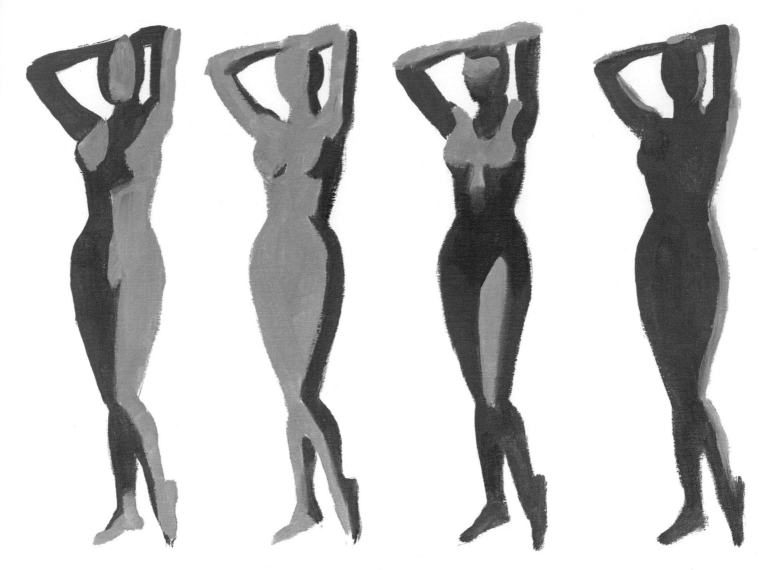

Lighting the Model

The series of figure diagrams shown here have all been lighted in a different manner and from a different direction. The first figure has been lit from the one side so that the shadow shapes are clearly defined on the opposite side. The second figure shows the light coming almost directly from the front so there is only a small shadow area. This is called flat light. The third figure is lit directly from above. The tops of the forearms and the top of the head, the shoulders, the breast and one leg that is projected forward are light struck while the rest of the figure is in shadow. In the last figure the light comes from behind so that we see the figure more or less in silhouette. However, most of the edges around the figure, particularly on the larger curving forms, will be softened with light.

There are many complex ways of lighting any pose, however, these four offer a good variety for figure work. Tricky lighting can become a hazard, particularly for the beginner. It is advisable, if you have any doubts about the effect, to keep it simple.

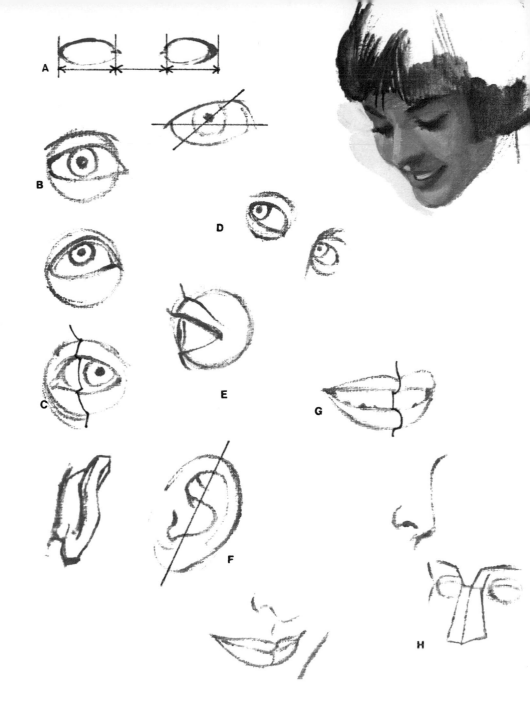

Features

The features all fit on the curve of the face, which is not a flat surface. The features tend to be irregular, soft and curved. There are no precise rules or measurements that are infallible but here are a few things to look for that may prove helpful.

A The length of each eye is about equal to the distance between the eyes.
B The inside of the eye towards the corner is wider from lid to lid than the opposite side.
C The lids are not pointed where they separate at the corners — they are rounded. Also, there is a definite thickness to the lids.

D When the head is viewed from a three-quarter position, the far eye is smaller than the closer eye.
E The eye we see is but a small area of the eye ball. As the eye moves the contour and appearance of the eye changes because of this rounded surface.
F The ear has a definite slant to it from top to bottom. It does not rest straight up and down on the head.
G The curve of the lips and mouth follows the curve of the teeth underneath.
H The simplest form of the nose is a wedge shape.

125

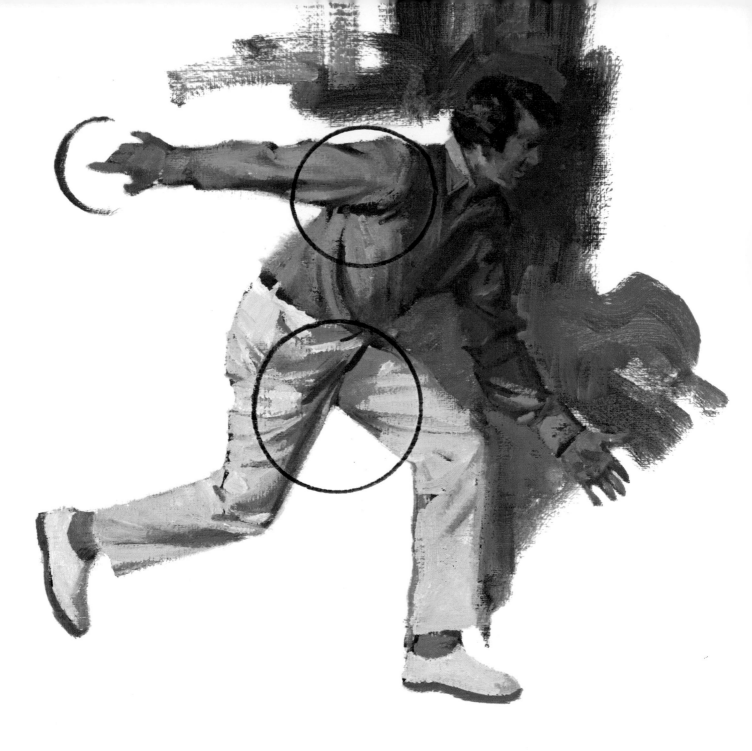

Folds from Stress

Often the action of the clothed figure is amplified by the folds that are created at various points of stress. The kinds and types of folds depend to a large degree on the kind and material of the garments being worn. In this sketch I've circled the major area of stress. At the crotch there is a radiation of folds leading out from the seams as the legs are spread. This exists, too, at the point of the armpit where the folds have been pulled away from the seam that surrounds the shoulder. These folds enhance the action, give animation and accent the movement of the figure.

When painting an action figure use the fold patterns to strengthen and accentuate the motion of the figure. Observing stop-action photographs can be a great help with this type of problem.

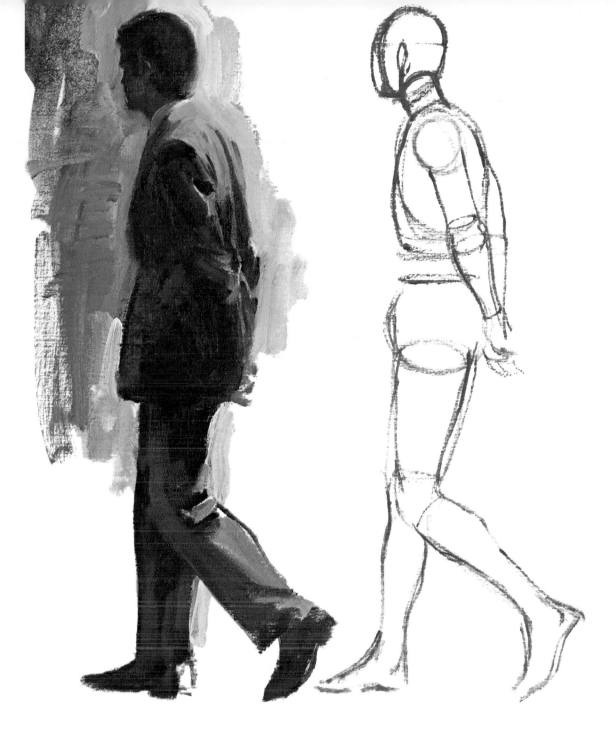

Passive Folds

In this case the clothed figure is walking rather slowly without a great amount of action. The folds are passive but they nonetheless help define and emphasize the form and action of the figure. The basic forms describe the influence of the figure under the clothing. For any kind of motion it is most helpful to use photographs for reference.

It is essential to simplify when rendering drapery. Study your model or reference material carefully. Look for the meaningful folds that help the action and eliminate the multitude of misleading wrinkles that are always present. With experience you'll learn indicating just a few bold folds at the right places is all you need to tell the story.

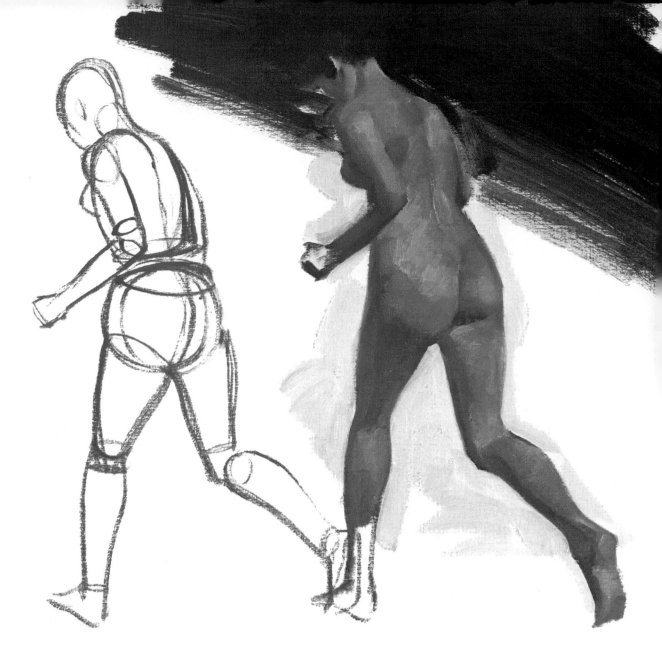

Basic Forms in Motion

It would be difficult to get a model to assume or hold a pose of this type, so it is necessary to use a photograph or other reference material. Also, using the basic forms helps in constructing and controlling the figure when interpreting an action you cannot observe directly. I find it helpful to try action poses myself. In this way you can *feel* and analyze how your body moves. It gives you a better understanding of what happens to all parts of the body and it makes it easier to construct the basic forms.

More Than One Figure

Compositions with two figures or more usually require an analysis of the relationship that exists between the people in the picture. The viewer will want to know what is going on — do these people know each other? what are they doing?, etc. The poses you select and how you group the figures are your major means of answering these questions. Of course, facial expressions and gestures are important but they are not paramount. The design of your picture, the positioning of the figures, how they overlap each other, their scale, the values and color all have a bearing on the solution. Whatever means you use the final result must not leave the viewer in doubt that there is a reason for this grouping and that a human relationship of some kind exists between the figures.

11 Various Techniques in Figure Painting

As we know, there is an infinite variety of directions, in concept and technique, that the individual artist can pursue even though the subject is the same.

The four paintings of nude figures pictured on the following pages illustrate this difference in approach. Each of these great artists allowed his own personal interpretation and taste to show itself; Rubens used ample forms and active composition; Degas utilized exquisite line and sensitivity; Gaugin, as a semi-primitive emphasized startling color and design; and Renoir bestowed a quiet grace and lyrical quality to everything he did.

There is a message here for the beginning artist. Look for and train yourself to "see" the basic fundamentals, beneath the surface technique, that makes a work outstanding, and study them. Composition, values, structure, and color can all be learned from others, but how you apply them is your own. Every artist develops a trademark in his method of handling that sets him apart. When this individuality is recognized and its integrity shines through, the artist's communication with those around him will be complete. I have not stressed technique in this book as you will develop your own the more you put paint to canvas. It's of no consequence whom you admire, whether it is Franz Hals or Grandma Moses. What is important is not to be self-conscious in your approach and to do it your own way.

Rubens
The Three Graces, 1639

Peter Paul Rubens, the 17th century Flemish artist is noted for his beautiful paintings of voluptuous, well endowed nudes. Although the criteria for the idealized female form seems to vary from age to age, there is no doubt Rubens was a master figure painter. I particularly admire his luminous flesh tones and the nuances of subtle hollows and curves that are so evident in this painting.

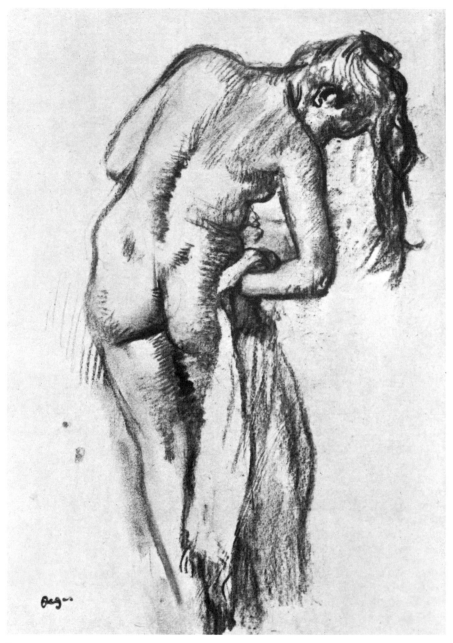

Degas
After the Bath
Charcoal
13⅞″ x 10″

Although Edgar Degas knew and worked with many of the early Impressionists in late 19th century Paris he is not classified in that School. He was a realist and a marvelous draughtsman who pursued his own course. This picture in charcoal is a beautifully controlled and powerful figure drawing.

132

Gaugin
Tahitian Women with Mango Blossoms

Paul Gaugin, another 19th century French painter, spent his last years in the South Seas. An unhappy and cynical man, his sarcasm made short work of his friendships. But, his only need was to paint and he dedicated himself to it. The natives of Tahiti and surrounding islands charmed him with their simplicity and good humor. His paintings describe this feeling with their vibrant color and bold approach. His sensitivity for the abstract is legend and his paintings should be studied for their color, design and simplicity.

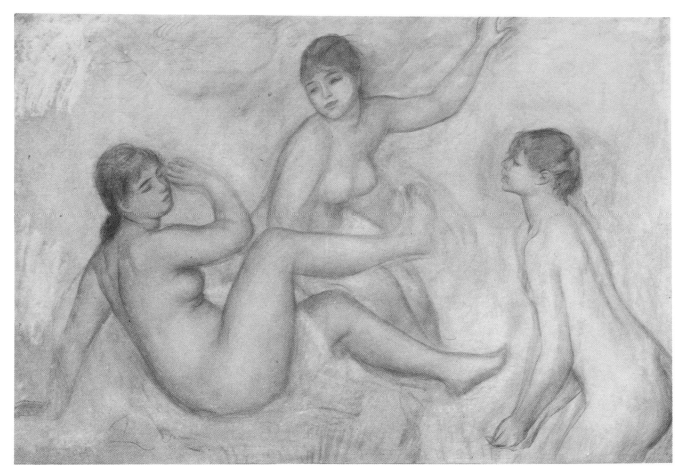

Renoir
Three Bathers
Pastel

Auguste Renoir was one of the leaders of French Impressionism in the late 19th century. He is noted for his brilliant color and lyrical compositions of women and children. This study in black and red chalk, heightened with white was a preparatory work for another painting. The emphasis on carefully defined contours and smooth textures tends to immobilize the figures in space.

134

12 Clothed or Draped Figures

When drawing or painting the clothed figure, remember that the surface and folds are affected by the body underneath. The surface will not be convincing if the viewer does not understand what the figure is doing. Certain easily recognizable folds are created by stress and action, particularly at the crotch, elbows and knees. But there are folds, too, that are caused by the seams of the garment as they resist the movement of the figure. The tightness or looseness of the clothing has a definite effect on folds as the tension varies. A man's suit will show few folds when he stands at attention. This will change quickly if he puts his hand in his jacket pocket and shifts his weight to one leg. Folds will form at the elbow and the line of the trousers will change. Folds will radiate from the button on the jacket to the pocket. The accuracy of placement of these folds then, helps to interpret and enforce the action of the figure.

Stand in front of a large mirror and take different positions. You will see how the folds change and you'll understand the reasons why the material slackens in one area and tension is created in another.

Different types of garments will cause different fold patterns. It depends on how they are supported by the figure as well as where the stress and tension occurs. The material itself will also affect what happens. Heavy woolen garments will have a different number of folds than silk clothes even if the cut and style is the same. Generally, the type of fold will be the same, particularly at the areas of stress and compression.

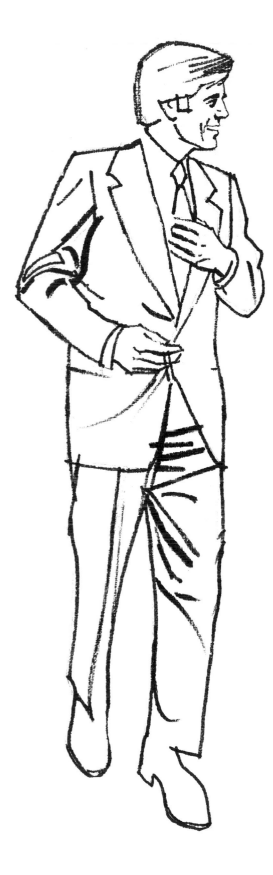

Movement

Here we see the excitement and mood that can be created in a figure by stressing stylized folds in the clothing. The action and movement of a figure can be enhanced with the proper use of folds. The walking figure has few folds but without them much of the feeling of movement is lost. The strongest and most obvious folds are at the compression of the elbow and the stress folds at the crotch. In simplifying folds and wrinkles don't forget the form underneath. The surface suggestions you make should amplify the underlying bulk.

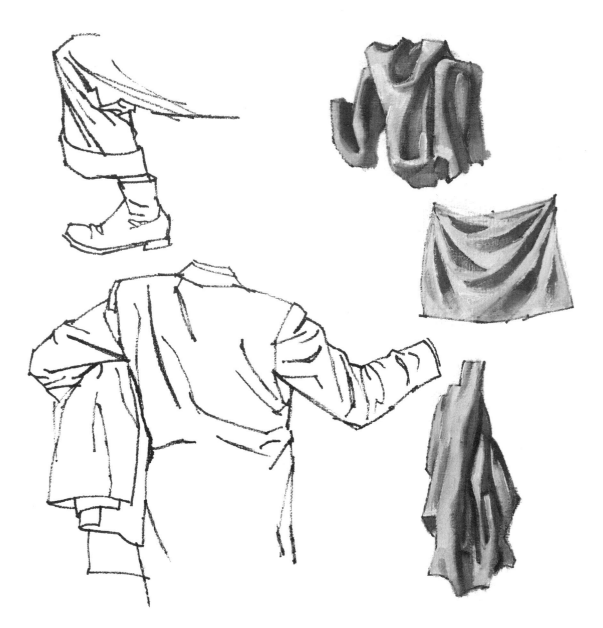

Types of Folds

Folds have been classified by artists and three major types you'll frequently see are (A) the lock fold, (B) the diaper fold and (C) drop fold. (Not illustrated but common also are pipe, zigzag, spiral and inert folds.) In the line drawings to the left I've shown where some of these folds will occur. The lock fold, caused by stress and compression, is formed usually as the knee bends in trousers and at the elbows. The diaper fold occurs at times on the back where the material hangs loosely from the shoulders. The drop fold is shown in the coat under the man's arm where it falls free affected by gravity rather than stress or compression.

Lighting on Folds

Drapery can be used in many varied and personal ways to strengthen the effectiveness of a picture. At times your approach may require the simplest suggestions of fold patterns and, on other occasions, the drapery can play a prominent part in creating a mood. The lighting you use will be an important consideration. A flat, or subdued light will minimize the folds, whereas, a strong, raking light will create deep shadows and sharp contrasts.

This demonstration sketch shows the kind of influence strong lighting creates on loose, bulky clothes. Drapery by itself is rather dull. But once cloth becomes associated with the figure it becomes "alive" and can contribute measurably to the quality of the picture.

This painting demonstrates the dramatic role folds and drapery can play in a composition. Note the impression of the bulk of the arms and body with but little detail or definition. The shapes and pattern of the folds are a major part of the picture design. They describe their function and also contribute color, rhythm and texture in a simple way.

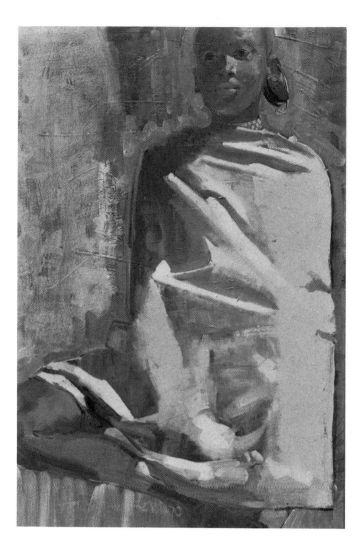

A Final Word

In the introduction of this book I mentioned that all the illustrations, descriptions and instruction would be kept as simple and straightforward as possible. I hope you found I lived up to this initial statement.

It is important to remember, however, that "reading one book does not an artist make" or doing one painting or a dozen. If you have the desire to arrive at your fullest potential, then practice and effort is the only way.

The books listed in the bibliography are all excellent for further, more advanced study of painting the figure and I strongly suggest you take advantage of them.

Good luck.

Howard K. Forsberg
Rio Rancho, New Mexico
1978

Bibliography

Baard, H. P., *Franz Hals, The Civic Guard Portrait Group*, MacMillan Co., New York, 1940

Bridgman, George B., *The Human Machine*, Dover Publications, New York, 1939

DeRuth, Jan, *Painting the Nude*, Watson Guptill, New York, 1967

Lane, James W., *Whistler*, Crown Publishers, New York, 1942

Mauclair, Camille, *Edgar Degas*, Hyperion Press, distributed by Duall, Sloan & Pearce, New York, 1945

Muybridge, E., *Human Figure in Motion*, Dover Publications, New York, 1955

Ormand, Richard, *John Singer Sargent, Drawings, Paintings, Watercolors*, Harper & Row, New York, 1970

Reed, Walt, *The Figure: An Artist's Approach To Drawing and Construction*, Watson Guptill, New York, 1976

Watson, Ernest W., *Color and Method in Painting*, Watson Guptill, New York, 1942

Index